# ROTHERHAM

# A POTTED HISTORY

JAMES BARKER

AMBERLEY

*This book is dedicated to the memory of my late father, Harry Barker, and my cousin Keith Jackson. You always believed in me and made me into the man I am today.*

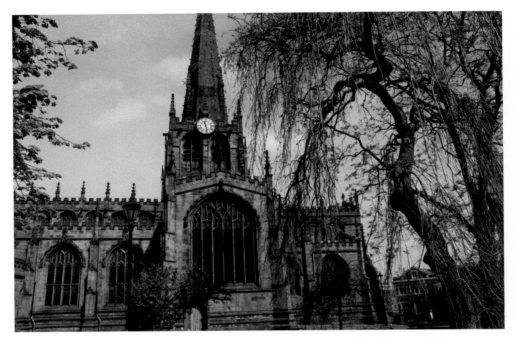

Rotherham Minster is still a focal point in the town and has seen much of the town's history.

First published 2023

Amberley Publishing
The Hill, Stroud
Gloucestershire, GL5 4EP

www.amberley-books.com

Copyright © James Barker, 2023

The right of James Barker to be identified as the
Author of this work has been asserted in accordance
with the Copyrights, Designs and Patents Act 1988.

ISBN  978 1 3981 1495 1 (print)
ISBN  978 1 3981 1496 8 (ebook)

British Library Cataloguing in Publication Data.
A catalogue record for this book is available from the
British Library.

Typesetting by SJmagic DESIGN SERVICES, India.
Printed in Great Britain.

# Contents

# Introduction

The area currently known as the town of Rotherham (officially known as the Metropolitan Borough of Rotherham) encompasses 110 square miles covering a large area ranging from its northern borders at Wath upon Dearne, across to its eastern edges at the village of Brinsworth, to its western borders at the village of Letwell and all the way to the village of Harthill at its most southern point. The last census by the Office of National Statistics in 2021 recorded a population of 265,800 which has been exponentially growing over

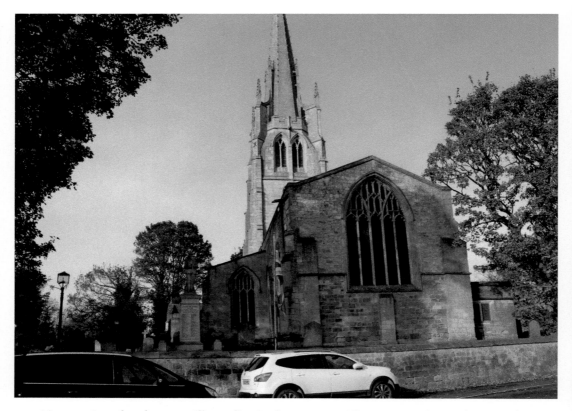

Many ancient churches are still standing in the town providing a connection to the past. This example is All Saints Church in Laughton en le Morthen.

the past two centuries. Throughout its long history Rotherham has always been a good example of how historical events can mould and shape a community. From its early days as a fortification for the invading Roman forces, to becoming a focal point for the ever-growing mining industry throughout the early twentieth century, Rotherham has always maintained a sense of community and purpose. Recently this purpose has altered due to the ever-changing nature of work, from heavy manual jobs relating to the coal and steel industries to becoming an area for upcoming enterprises to place their roots. This book will aim to provide the reader with a short history of Rotherham, including the interesting characters and events that have shaped the town from the perspective of a Rotherham native.

# Early Civilisation
# (Prehistoric–AD 100)

Before human civilisation expanded to its current level, the UK, including Rotherham, was covered with a vast expanse of woodland (termed the wildwood) for thousands of years up until 4000 BC. The wildwood would have stretched the full length of the UK and contained a large variety of mammals, birds and insects, many of whom are rare to see in today's landscape. The woods started to develop as soon as the glaciers melted around 11,000 BC. Many different species of wildlife flourished during this time, making the local area unrecognisable to the arable farmland currently seen through the borough of Rotherham.

The woodland in Anston Stones provides a haven for nature just next to the A57. It is home to a variety of plant and wildlife species as shown in this photograph.

The local area was dominated by two distinct tree species, consisting of oak-hazel and lime. Remnants of the lime tree *Tilia Cordata* can be found at the Roache Abbey site near Maltby and at Anston Stones between the villages of North Anston and South Anston as well as ancient yew. The woods at these locations have been largely undisturbed for many years and give an idea of what a tree-dominated landscape would have looked like. Remnants of a Stone Age settlement have been found at this location as well as numerous hunting artifacts in an area known as Dead Man's Cave.

As human civilisation expanded across the UK, the wildwood started to be cut down to make way for living space and farming land needed to supply the ever-expanding population. This began in around 4000 BC and carried on until the majority of the woodland had been removed across the borough. This made way for other industries to take off in the area, such as the beginning of mining and arable farming. The earliest examples of civilisation can be found in Rotherham around the Neolithic period in Dinnington where an ancient barrow was discovered in 1862. Excavation revealed twenty skeletons of all ages buried together. The location was near Park Avenue Road, although this area is now wooded and consisted of a barrow approximately 8 feet high and 42 yards long.

The original spelling of Rotherham in its early history was Rodreham, meaning 'homestead on the Rother' in Old English. Much of the town's early history is steeped

These rocks, Anston Stones, have been here for eons and provide a tangible reminder of the past.

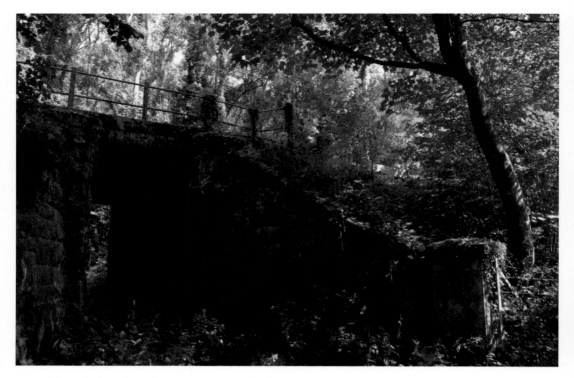

Although there have been structures built throughout Anston Stones, nature still has a way of reclaiming it.

in speculation as not a lot of records exist, although some information can be gleaned from objects found from the time. For example, pottery and an ancient Roman wall was unearthed in the village of Brinsworth in 1951. One of the earliest global events Rotherham experienced during its early history was the invasion of Britain by the Romans between AD 43 to AD 84, from which Rotherham was not spared. One of the largest settlements to be established in the early history of Rotherham was a Roman fortification built in AD 54 in the area now known as Templeborough. It appears that the fort was initially a temporary structure located on the banks of the River Don and used by the Roman soldiers in the area, possibly for reconnaissance and to help keep order in the local area. The structure was replaced with a permanent stone fort in AD 100 and appears to have had a military presence stationed there until the Romans evacuated Britain in AD 409. Many interesting items have been found at this location, including roof tiles stamped with craftsmen's symbols. The construction of this fort reveals Rotherham to be an important focal point even during this time period, helped by the fact that it has always been close to important road networks throughout early history, such as Ryknield Street connecting pre-Roman Wales to the River Tyne.

The surrounding area of the fort was left practically untouched as it was known to be difficult to farm due to the remaining stones from the fort structure being embedded in the ground. This created a problem for the local people who wanted to use the land for

agriculture, although it helped to preserve the remains of the fort until it was excavated during the twentieth century.

Another early human activity across Rotherham has been found in areas such as Canklow Hill where evidence of Iron Age artifacts has been found. The place names in the area also hint at Norse and Saxon origins and examples can be seen throughout Rotherham, such as Thorpe Hesley (village in the horse clearing) and Ulley (owl clearing). Further examples include the word 'gate' being used in place names to denote a Norse street, such as in Wellgate. Another popular name present in many of the town's villages is 'Morthen', which according to the literature means 'killing fields'. This can help to give us an idea of how long certain areas in Rotherham have been settled where there may not be extensive records available.

Canklow Woods is also rumoured to be the location of an Iron Age settlement containing artifacts such as Mesolithic flint which most likely would have been the remnants of ancient tools or weapons. This is just a small snapshot of how life was during the early days of the town's history.

Rotherham has its fair share of myths and legends from this period, including some steeped in historical events. The current border of Brinsworth and Catcliffe has been rumoured to be a possible location of the influential Battle of Brunanburh which saw a major battle between the reigning regent of the area, King Athelstan, against the local Norsemen. There are many different locations across the country that also share this legend, although Rotherham can say it is home to historically referenced material hinting that the battle's location was within its borders.

# Founding of a Market Town
## (100–1200)

One of the earliest mentions of the town is in the Domesday Book of 1086, which notes there being twelve households as well as the areas of Kimberworth (known as Chiberworde) and Brinworth (Brinesford) being already established at this time. Rotherham as it is known today was on the border of two Anglo-Saxon kingdoms: Mercia and Northumbria. Although not a large settlement at this point, it would have been exposed to foot traffic from both kingdoms as well as opportunities to trade between the two states.

This period in history showed a steady increase in Rotherham's overall population, due to local villages slowly expanding as they were able to sustain more people due to the advent of better farming techniques. Rotherham at the time consisted of many different townships, including the aforementioned Brinsworth and Kimberworth, as well as numerous landowners who presided over each manor.

After the successful invasion of Britain by William the Conqueror in 1066, the ownership of all the estates that made up Rotherham was given to the Count Robert of Mortain, brother of William, who in turn gave stewardship to Nigel Fossard. From

One of the earliest recorded mentions of the town was in the Domesday Book in 1086, listed as Rodreham. (Image courtesy of Professor John Palmer, George Slater, Anna Powell-Smith or opendomesday.org)

surviving records, Rotherham had an established church and mill at this time showing that it was already starting to develop as a successful township.

The other estates that make up the current town of Rotherham were given to other influential individuals at the time, such as Kimberworth being handed to Roger de Busli. As time went on the stewardship of Rotherham's estates fell to the de Vesci family until full ownership was achieved in the eleventh century. This was to start a long-standing feud between two rival families over who owned vast swathes of land in the Rotherham area: the de Vescis and the de Tillis. The origins of this dispute can be traced back to 1242 when the de Tilli family lost their lands in the Rotherham area due to a disagreement with the current monarch, King John. These lands eventually went to John de Lexington whose brother would become the first official vicar of the town. By 1250 Lexington had given his half of the town to Rufford Abbey shortly followed by the de Vescis in around 1270. After many years of the town and church being split between various landowners, the two halves of the church were brought together by the Abbey of Rufford in 1355. Before this date it was known that two priests had served in the town's main church, but following this amalgamation a vicar and rector were established. The first vicar of the unified church in Rotherham was John de Fledburgh. The tower of the church was Constructed in 1409 by order of the Archbishop of York, most likely to ensure that the structure remained an impressive sight for the local population and for any visitors to

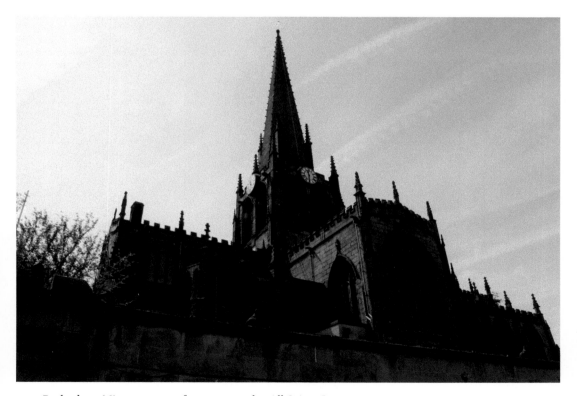

Rotherham Minster as seen from current day All Saints Square.

the town. The Archbishop also appealed to the local populace for help with this building project, and the outcomes of this work can still be seen today.

Although Rotherham Minster would be classed as the main place of worship for Rotherham and its local townships at this time, it would not be the only structure built to enable the local population to practice their religion. Chapels of ease were built in the local townships to provide a more convenient location for people to pray and attend services, as the transport network was non-existent and travel to the town's central church could take many hours depending how far away the parishioner lived.

Transport would also have been an issue, and many families would not have been able to afford to pay for a horse and cart ride to the church every week. Notable examples of these chapels have been recorded as being present in populated areas of the time including Greasbrough. Priests played an important role in the community and would have been seen as a source of support in non-religious matters; for example, when local floods devasted people's homes and livelihoods it has been recorded that they helped with the aftermath by offering support to the local community.

There are no specific records to say when the initial church was built in Rotherham on the current site of Rotherham Minster, although from documents it can be seen to be over

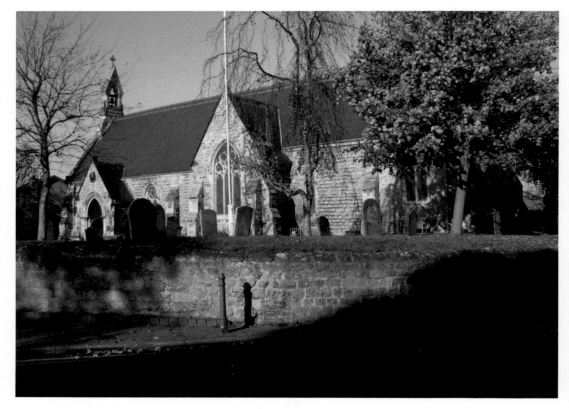

St Leonard's Church in Dinnington is an example of a local place of worship that has been used by the local people throughout Rotherham's history.

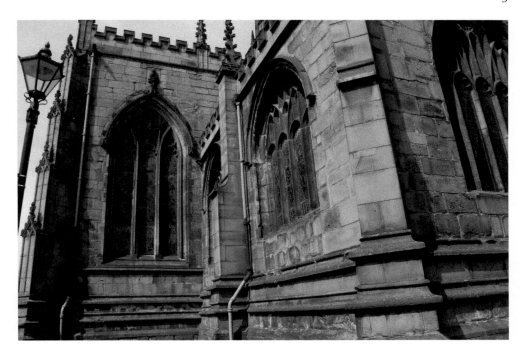

*Above*: Rotherham Minster, also known as the parish church, is home to some impressive architecture which has stood the test of time.

*Right*: One of the ornate stained-glass windows as seen from the outside.

a thousand years old. Rotherham Minster celebrated its 1,000th anniversary in 1937 based on an approximate date of its founding.

Rotherham has always been home to an industrious population, using the resources of the area and learned techniques to utilise their lot in life. The earliest signs of this industrious spirit can be seen in the early eleventh century when the monks of Rufford moved to the area and were granted rites to use the land in Rotherham for keeping livestock and to find and use local iron ore deposits. This was granted by the landowner of the Manor of Kimberworth at the time called Richard de Dusli (historical records may have written this name incorrect and meant to refer to Roger de Busli). Records have also stated that monks also occupied an area at Thorpe Common, most widely known as Kirkstead Abbey Grange.

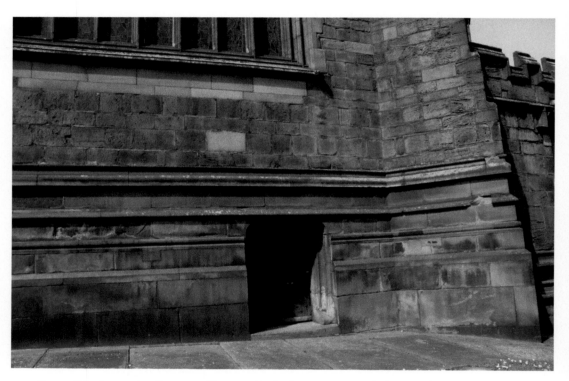

Some of the interesting features still seen at Rotherham Minster include a small door on the side of the building. Could this have been used as a goods entrance at some point in history?

# 3

# Expansion and Innovation
# (1201–1900)

Rotherham kept expanding during this period as the area started to develop its expertise in various industries. Religion and industry played equal parts in developing the region into what it has become today.

The site that would become Roche Abbey was first surveyed by Cistercian monks from Newminster Abbey in the twelfth century where it was rumoured that they saw a religious image of a consecrated cross in the rocky crag at the site before deciding to settle

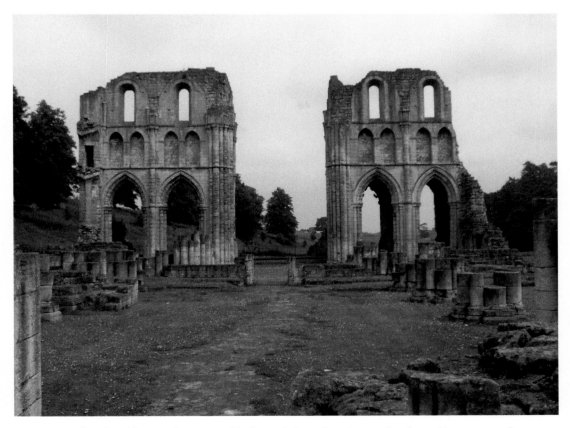

Ruins of Roche Abbey can be seen to this day and shows how impressive the architecture was from that time. (Thank you to English Heritage for allowing photography at this site)

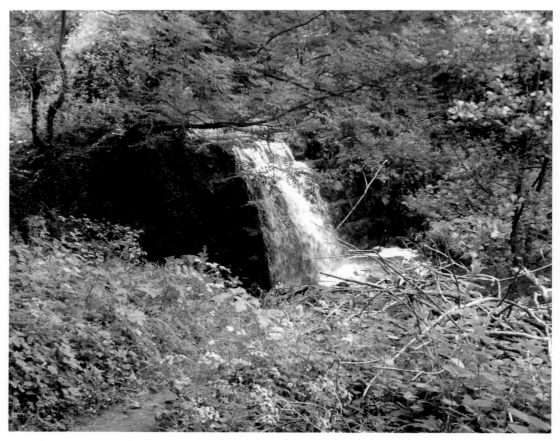

The walk around the ancient woodland at Roche Abbey takes you to a waterfall. Could this have been the location where the monks saw the image of the cross?

in the area. Visiting the abbey today, you can walk around the ancient yew woodland and can see many locations where this folktale may have occurred.

The meaning of Roche is 'rock', although the original name of the site was the Abbey of Santa Maria de Rupe. The abbey was demolished during Henry VIII's Dissolution of the Monasteries after two visits by the King's emissaries Doctors Leyton and Leigh. The Abbey was spared the massacres seen at other religious sites at the time and it was noted that many of the monks were given pensions and removed from the site in 1537. Local people took advantage of this event by recycling the stone to build nearby homes. A hunting lodge was built on the site in the 1760s and is now the main reception building.

An interesting fact is that many of the underground tunnels used by the monks for safety in time of persecution are still there to this day, although the entrance to them has long since been blocked. The Abbey ruins are still impressive and give a glimpse of how it may have looked before its destruction. A small coffin-shaped stone lies in the middle of the ruins, and local legend says a face will appear if you stare long enough into its recess.

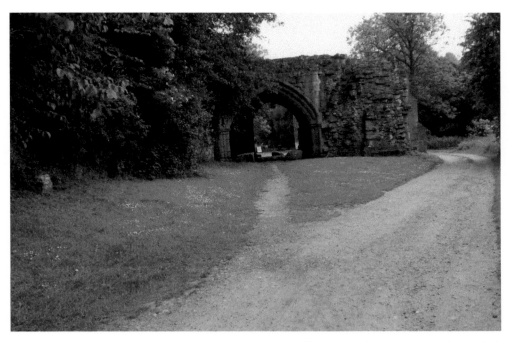

The remains of the entranceway to Roche Abbey. This still serves as the entrance to the English Heritage site and provides an appropriate introduction to the abbey.

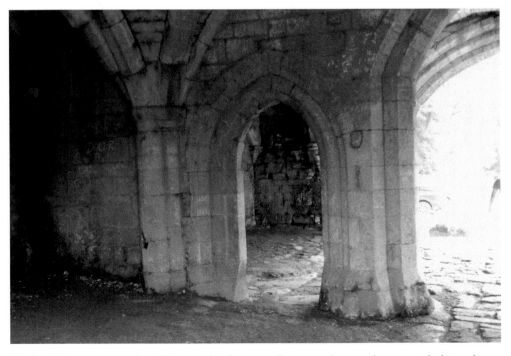

Much of the entranceway is still intact with the original stonework, as can be seen with this archway.

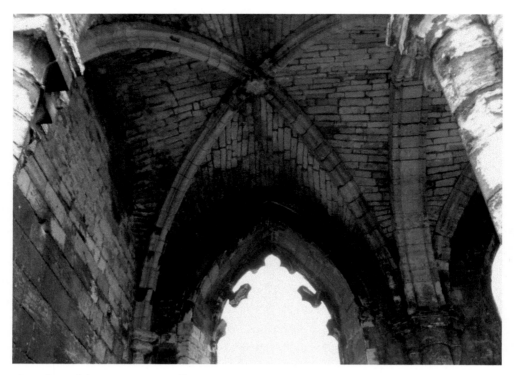

The ceiling of the entranceway still has its intricate detailing.

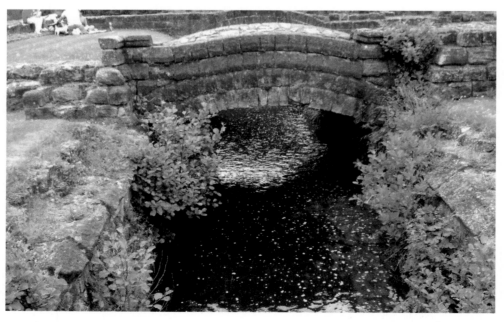

Near the small coffin a brook runs through the abbey. This would have provided the monks with a close source of fresh water.

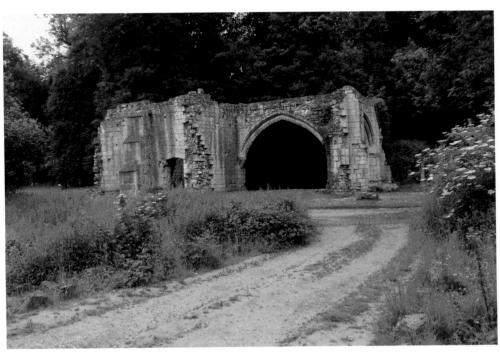

Other ruins of various buildings exist at the site providing an idea of what the abbey layout could have been.

Side view of the Chapel on the Bridge. Much of the structure is in excellent condition.

The introduction of a new iteration of the poll tax in England during the fourteenth century gave the government a steady income based on how many people lived in each town and city. Records from this time show that the population of the Rotherham township, not covering the same area it does today, was around 365 people. The total population that includes all other townships making up the modern-day borough would have been around 1,000 people as areas such as Brinsworth were still classified as separate areas.

One of the most famous landmarks in Rotherham is the Chapel of Our Lady on Rotherham Bridge, a Grade I-listed building which is included in much of the town's promotional material and is one of the only remaining chapels of this style currently in existence.

The original bridge on this site predates the church as it was recorded as having been present in documents going as far back as 1483 when the chapel itself was constructed. The chapel was built of locally sourced sandstone and a crypt was also built which can be viewed today. This crypt can still be accessed by taking some small steps downwards on the left-hand side of the entrance to the chapel. Chanty chapels were officially dissolved by Edward VI by the Chantries Act of 1547 which saw the chapel being boarded up and largely abandoned. It was later transformed into an almshouse in 1569 to provide charity housing to poor members of the town who had nowhere to stay. In 1779 the purpose of the building was changed again into a prison house. Two cells were built in the crypt of the chapel with the serving constable staying in a room that was a floor above which would have provided easy access to the nearby street. During this time the name of Gaol Bridge

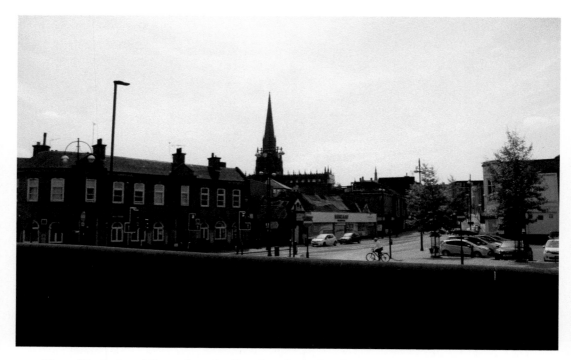

View of Rotherham Minster from the Chapel on the Bridge showing their proximity to each other.

was given due to the nature of how it was used. There is no doubt that the chapel became a place of dread for the local population.

A visit to the chapel today will show you cell doors still engraved with the names of people held here as well as providing an insight into the claustrophobic conditions experienced by the inmates.

Later reiterations of the chapel include it becoming a courthouse in the 1820s, as well as a tobacconist during the early twentieth century until 1913 when it was closed. After this time there was a concerted effort to restore the chapel with work beginning in 1924, and in the same year the chapel was reconsecrated by the Lord Bishop of Sheffield. The bridge where the chapel resides was also upgraded to help it cope with the stresses of modern traffic and was closed in 1928 for construction works to commence. A new addition to the medieval bridge was added, the Chantry Bridge, and was opened to the public on 28 April 1930.

One of the most influential characters to be born in the Rotherham area was Thomas Rotherham, born on 24 August 1423. He was educated at Kings College in Cambridge and also later studied at Oxford where he completed a doctorate. Being an orthodox Catholic he eventually entered the church and became Archbishop of York in 1480. During his long career he also helped to write the statutes for Lincoln College at the University of

Entrance to the Chapel of Our Lady on the Bridge showing its traditional wooden door and commemorative plaque.

The bridge where the chapel sits, as well as the River Don, has had many works completed over the years. This picture shows where soil has built up and been placed where once the river flowed, most likely to ensure the survival of the chapel during heavy rains.

Oxford. Thomas never forgot his roots and wanted to give back to the town which had given him so much during his formative years. To do this he proposed the foundation of a college in Rotherham consisting of three schools: a grammar school to provide free education to local boys, a free song school to help local gifted children express their musical creativity, and a further free school to help the area with its education offer. The college also provided the local people with a place to worship.

Although Rotherham Minster existed at this time, the closest Abbey to the town was over 8 miles away at Roche Abbey near modern-day Maltby (the ruins of which can still be visited today). To also help spread his religious ideals he endowed a new chapel in Rotherham Minster called the Chapel of Jesus which was opened in 1480. A Norman font dating back to the twelfth century in which Thomas was baptised can still be seen in the church today. Thomas Rotherham died on 29 May 1500 after contracting the plague and was buried in York Minster. The college he had worked hard to build passed into different ownership and changed into the Feoffees of the College of Jesus of Rotherham. The college was dissolved in 1547 although Thomas Rotherham College, which can find its roots in the grammar school mentioned earlier, still bears his name and is one of the highest rated educational institutions in the area for post-sixteen qualifications.

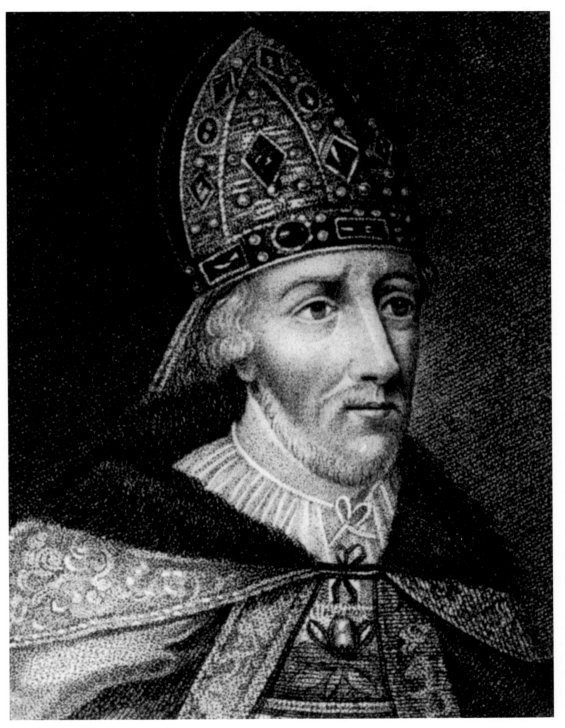

Portrait of Thomas Rotherham during his time with the church. (Thank you to Rotherham Archives for use of these images)

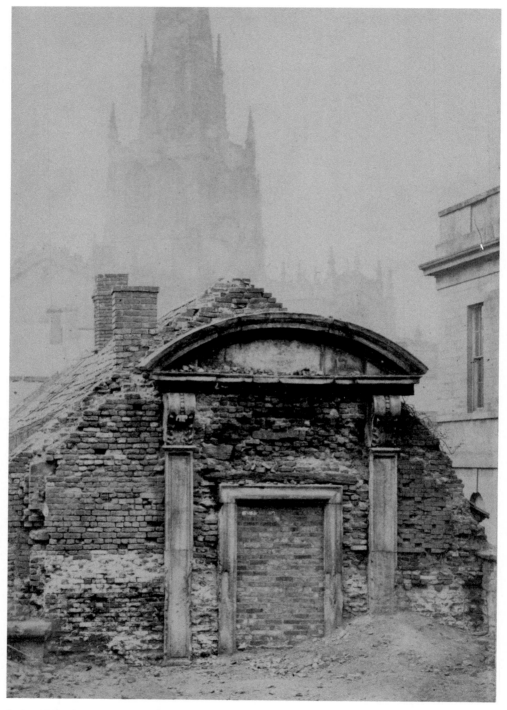

Ruins of the doorway to the College of Jesus can be seen in this old photograph most likely taken in the early twentieth century. Note Rotherham Minster can be seen in the background. (Thank you to Rotherham Archives for use of these images)

Plague ravaged the country during the fourteenth century, causing widespread death, disease and destroying many villages throughout this period. Rotherham did not avoid the sting of the plague and cases in the area have been recorded in 1570 and 1589. Records from the time mention isolation huts being set up in the town and were noted as being present on the Town Moor most likely close to the modern-day centre of the town.

Rufford Abbey, an important religious institution in Nottinghamshire, was dismantled during the Dissolution of Monasteries by Henry VIII in 1536, which ended its long association with Rotherham and its people. The Abbey had a lucrative share in the town as it had been recorded that the annual income it received from the populace would have been £143. Given that it can be estimated £1 would be worth approximately £267 in 1550, the abbey had a total income of around £38,000. The Abbey also had various assets in the local area, such as five forges, bakeries and stone quarries in the vicinity of Doncaster Gate.

In 1537 the responsibility of the Rotherham estate was handed to George Talbot, the Earl of Shrewsbury, who also had ownership of the manor and castle of Sheffield. The current state of Rotherham can be seen in John Leland's account of his visit to Rotherham on behalf of Henry VIII, where he noted that there were many coal mining enterprises in and around the town by stating there were 'good pits of coal' and also a 'fair stone bridge of four arches' most likely referencing the modern-day Chapel on the Bridge.

Deer parks were widespread across the region in the sixteenth and seventeenth centuries, used by wealthy landowners as a source of game for hunting as well as a social pastime. The parks were classed as private land and not part of the more widespread common land in the area, so its use by the general population was restricted. Deer park boundaries were organised depending on who owned the land and have been noted as being present in many areas, such as Kimberworth Park (700 acres in the early 1600s). A deer park was also known to exist in the area of Maltby, covering 110 acres, as it was mentioned in documents relating to the nearby abbey (Roche Abbey) around 1215. As we neared the late sixteenth and seventeenth centuries, many deer parks were turned over for farming and later for coal mining as the local population shifted occupation and industry became more widespread in the area.

An interesting structure that is no longer seen in today's town is the corn windmills used by millers to produce flour, animal feed and other products destined for the local community. Types of these structures were seen near areas such as the village of Woodhall and Harthill in the late fifteenth century. Unfortunately these locations are hard to find in today's landscape. This is another example of a livelihood and profession that is now lost to the passage of time. It has been noted that many dovecotes (usually a wooden structure traditionally painted in white), used to house doves and pigeons, existed across the Rotherham area, such as at Todwick Hall in 1720 and Holme Farm in the small village of Brampton-en-le-Morthen. These would have been far more commonplace than today where it is rare to see one in the town.

Dissolution of the chantries in 1548 reduced the power of various religious groups and Abbeys in the area, making way for Rotherham to be governed by the Feoffees of the Common Lands of Rotherham. This group would govern the town for over 400 years, from the sixteenth to the nineteenth century. In essence they provided services similar to that of a local government before official entities like this existed. Records show the

Feoffees being successful in governing the town, for example, repairing and maintaining buildings and roads and maintaining the wells in the area. The group still exists to this day, although it is now mostly involved in charitable work relating to the town.

Maintenance of the various roads and canals in the town fell to whichever group was governing the town at the time. The year 1555 saw the introduction of a law which required any householder in the town to work four days' labour a year to help maintain the various road networks. Many people will have no doubt done this unwillingly, although it was clearly an essential job needed to maintain the transport networks during this time. Before this law there wasn't any widespread legislation designed to help maintain the transport infrastructure, which meant that many roads became difficult to navigate, especially during the winter months, periods of heavy rain or during droughts when the roads were known to become dusty. The impact of an unmaintained road could be disastrous, from broken carriage wheels to massive delays for coach passengers. At the time a horse and cart would average around 2mph due to the terrible road conditions and would have added significant time to already long journeys.

Another strategy adopted in Rotherham during the 1700s to help with the roads was to introduce toll houses. These were designed to raise funds to help maintain the road network by charging people to use certain roads in the town. Examples of these include a toll house on Bradgate Lane near the centre of the town, a toll at Whiston Crossroads and another located at the west end of Wentworth.

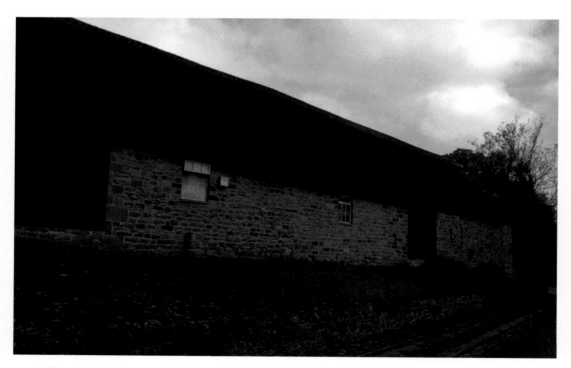

Whiston is also home to the Manorial Barn which is one of the oldest buildings in the town, dating from the thirteenth century.

Crime in the Rotherham area has been recorded back as far as its early history. One of the most notable events that left a lasting impression on the town was the terror spread by notorious highwayman John Nevison at the end of the sixteenth century. The highwayman's gang operated out of Newark and was noted as committing crimes in Maltby as well as in the centre of Rotherham. His crimes in the main town consisted of the robbery of a butcher who was on his way to take part in the market that week. John was arrested a number of times and his crimes eventually caught up with him when he was executed in York by hanging in 1684.

Religion has always played an important role in the lives of the people of Rotherham. Although the population was primarily Church of England and Anglican throughout much of its history, it has been known that the Quakers were active with a congregation in Rotherham from the sixteenth century onwards, with one renowned member, Elizabeth Hooton, being noted as having an active congregation in 1652. One of the earliest congregations to have their own meeting house has been recorded as being the Presbyterians and Unitarians in 1704. The main place of worship for the population at this time was Rotherham Minster, although there were many other places of worship across the town. The year 1879 saw the construction of a new church in Moorgate, the Church of our Father, which was a replacement for an older chapel that was previously located on Down Row. The building itself still exists today and has been converted into a mosque. Further afield, areas of Rotherham also had substantial places of worship, including the Masbrough Independent Chapel that was rebuilt in 1777. This building is also still present as a carpet warehouse in the town.

Although the town did not play a direct role in the English Civil War between 1642 and 1651, many changes and events happened in this period which influenced the town and its inhabitants. During this time there were changes to the lords who owned the manors in the Rotherham area. One notable resident was the Reverend Jon Shaw, who was a well-known Parliamentarian. During the Civil War part of the Royalist force attacked an area near Barnsley, which caused concern among the population of Rotherham. In response to this event the town's people erected earthworks to prevent the encroaching force from taking the area. This foresight would prove to be well placed when the Royalists attacked the town on 22 January 1643. The invading force came from the directions of Doncaster in the east and Pontefract in the north, both at the time Royalist strongholds. It has been noted in local records that the local congregation of Rotherham took up arms against the Royalists. By spring of 1643 the King's Royalist commander in the north of England, Will Cavendish, the Earl of Newcastle, moved his force to Rotherham to aid in the attack on Sheffield Castle. It is recorded that 8,000 men accompanied the commander for this task, and it must have filled the local townspeople with dread after hearing this news. The force was successful in gaining ground and successfully went through Masbrough in May 1643, making their way to the centre of the town. When they reached Chantry Bridge, one of the main thoroughfares, they encountered a blockade set up by the local populace including members of the local grammar school. Against all odds they held back the Royalists for two full days, until they were overpowered. The Chapel on the Bridge still bears scars from the musket and cannon fire which would have most likely happened during this battle.

The Chapel of Our Lady on the Bridge still consists of much of its original stone. It has been noted that musket shot marks from the Civil War period can be seen in the stone. Could these marks be from such an event?

A treaty was signed shortly after which unfortunately led to the town being plundered by the invading force. This was a major event in local history, as it was the precursor to the fall of Sheffield Castle on 11 August 1643. Similar to many towns and cities in England at the time, the English Civil War had a devastating impact on the local economy and would affect it for many years to come.

Rotherham has had many famous characters from history visit the town, such as Mary, Queen of Scots who visited in 1568. Mary was travelling from Boston Castle heading towards Tutbury Castle on her way to a pressing engagement. A long-standing myth in the town is that Mary stayed at the Chapel on the Bridge during her time here, although this is most likely incorrect due to the number of rich landowners owning manor houses in the town who would have no doubt wanted to make a good impression on the royal guest. Mary did include mentions of Rotherham in her personal correspondence and stated that there was pestilence present in the town, most likely caused by the rampant poverty and poor living conditions. Another famous royal visitor was Charles I who was kept overnight in the town on his journey south as a prisoner in February 1647 as a result of the English Civil War.

Local libraries are still a cornerstone of the community; they were first established in 1728 at the parish church in the centre of Rotherham. Although this will have been a

small-scale affair, it must have proved popular as libraries in the region have expanded to over eight sites in the present day.

The River Don has always been an important lifeline for Rotherham, providing a source of water and transport into the town for many centuries. Its vast use by local industries and the population guaranteed that major changes had to be implemented to the river in the 1700s to increase its functionality.

The changes enacted were not agreed by all businesses, especially any mills or other industries that already used the River Don and were going to be negatively impacted by the new building work. The above works helped to transform the canal into the network of waterways we see today and enabled vast amounts of goods to be taken far and wide. One of the most notable examples is in 1769 when it was reported around 30,000 tons of coal was transported from Rotherham to Gainsborough, helping to cement Rotherham as a producer of raw materials needed across the country. During the 1770s Fenton Pits produced around 166,395 wagons of coal which were then transported on the River Don to Greasbrough, proving how integral the canal was to all industries in Rotherham.

The River Don flows through Rotherham, past Forge Island and under the Chapel on the Bridge before it continues on its journey.

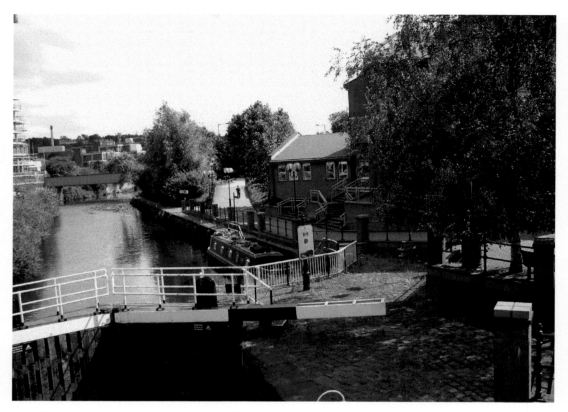

The main canal in Rotherham can still be seen today and is very accessible through the walking routes.

Chesterfield Canal also connected to the south of what is now in the Rotherham Borough, and its origins can be found in the village of Kiveton Park. Construction of the canal started in 1771 and once finished it consisted of a total of 46 miles of canal way separated by sixty-five locks. This provided a network to the town of Worksop and up to Chesterfield providing another route for businesses to ship cargo and raw materials rather than by the usual method of packhorses. One of the most innovative parts of this canal, the Norwood Tunnel, had one of its entrances near Kiveton Park. This tunnel was an impressive piece of engineering consisting of 2,850 yards of continuous tunnel, taking three years to complete. At the time of its construction it was the longest tunnel in Europe. The main port used to ship goods from Rotherham was Gainsborough, although it has been noted that Bawtry Wharf was used during summer months when the road was passable.

The oldest timber building currently still standing in Rotherham is the old public house The Three Cranes on ship hill, which was originally built in 1470.

In 2015 the building was reopened after being purchased as a store by Hanby's Antiques. The store contained many interesting artefacts from across the twentieth century, as well as access up a stairwell to the top floor which brought you into an old

The original route of the Chesterfield Canal is still in place today. It is now home to an extensive walk which covers over 46 miles.

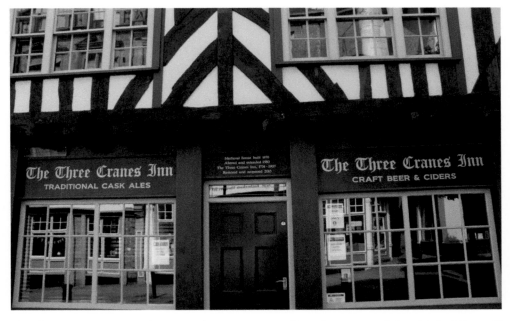

The Three Cranes as it can be seen today. Restoration efforts have ensured that this building still remains as an important landmark in Rotherham's history.

attic room containing ancient timber beams and a disused fireplace. This area had been left largely untouched and gave you an idea of what this space could have looked like during its many years as a pub. At the time of writing this building is closed to the public, although this author hopes that this will be reopened in the future so that the building's fascinating history can be explored by the town's residents.

The first established market to have taken place in Rotherham was in 1306. Rotherham had a wide variety of visiting markets throughout the centuries, including the beast market that visited the area that is now present-day Wellgate in 1777, selling mainly livestock.

The marketplace in old Rotherham town had many items that would be unheard of today, such as stocks and a pillory for anyone convicted of a crime. Many of the dwellings of the town at this time would have been constructed primarily of wood, including any local places of worship. More severe forms of punishment such as the gallows were also present in various areas of the town. One notable example is the gallows that was present in the modern-day village of Laughton Common. It is believed the village's name came from the Old English for 'Law Town', which suggests this area was a seat of judicial law for the local villages. Records show that this was an important area in terms of local

Hamby's shoe shop has been a well-known landmark in the town for many years. The location is now used by an independent tattoo shop.

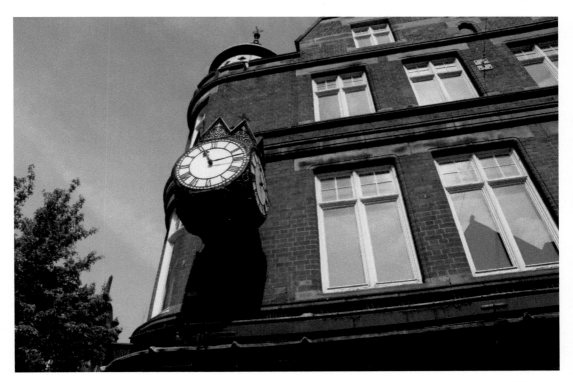

The famous Hastings clock, first built in the early twentieth century, is now Grade II listed. This is a familiar site in many of the archive pictures and its preservation helps to keep a link to the past alive.

governance as Laughton Castle was located near All Saints Church in Laughton-en-le-Morthen just up the hill from where the suspected location of the gallows was located. The remnants of the castle were unearthed in 1977 and showed evidence of there being a moat and courtyard present. A local pub, aptly named The Gallows, stands on this location marking an important part of the village's history.

Before the eighteenth century much of the land in and around Rotherham was classed as common land, enabling the landowners to raise crops and graze livestock. The late 1700s saw the enclosure of much of these areas due to owners wanting to manage their lands more easily and most likely to prevent other residents from using it.

Although coal mining will be discussed extensively in the next chapter, it is worth noting that coal mining was first recorded as occurring in the area as early as the late medieval period. The earliest pits in the area would have been shallow or drift mines that would not have required a winding gear to allow men access to the mine. The collieries were owned by wealthy families in the area, including the Wentworth estate which recorded mining activity as early as the 1740s. This predates many of the major collieries that would be developed in Rotherham over the next two centuries and could have provided a template for how mining would develop further in the area. It has been noted that the technique of boring was used as early as the 1790s to find undiscovered coal

seams. The lack of technological solutions at this point made the job extremely difficult and hazardous. Wealthy landowners were some of the first pioneers in coal mining in the area due to the vast amounts of money needed to start up in this venture. Historical records also show that there were small collieries located on the border of the town at Carr House in 1740.

No history of Rotherham would be complete without a mention of one of the most influential and wealthy families to live in the town: the Wentworths. The Wentworths have resided in the Rotherham area since before the English Civil War and have lived at Wentworth Woodhouse since the 1400s. One of the most notable members of the family was the 1st Marquis of Rockingham, Thomas Watson-Wentworth, born in 1693. He had a varied career including being an MP for a short time in Malton between 1715 and 1727 and for the entire county of Yorkshire between 1727 and 1728. He is also responsible for how the famous house Wentworth Woodhouse looks today as he commissioned much of its structure and expanded it to include two mansions, one in the Baroque style and the well-known Palladian Mansion which people associate with the main entrance.

Over the course of his life, Thomas would build a keeper's lodge as well as some of the famous Wentworth Follies, consisting of Hoober Stand, built in honour of the suppression of the Jacobite Rebellion in 1745. Other follies built around the estate include Keppel's Column (built 1773), the Needle Eye (built in the eighteenth century) and the impressive Rockingham Mausoleum (constructed in 1783).

Present-day Rotherham market is still a popular place for people to grab essential items.

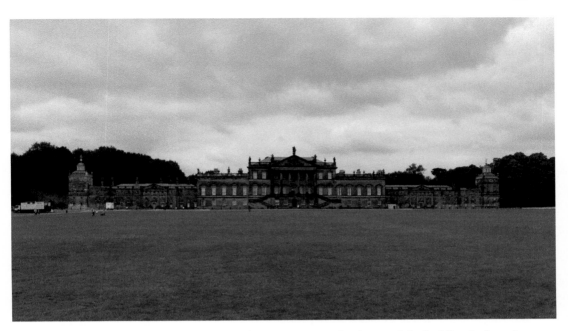

The impressive front of Wentworth Woodhouse is over 130 feet long and the building is classed as Grade I listed.

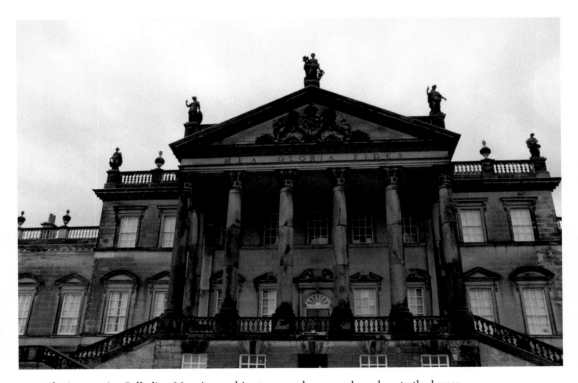

The impressive Palladian Mansion architecture can be seen when close to the house.

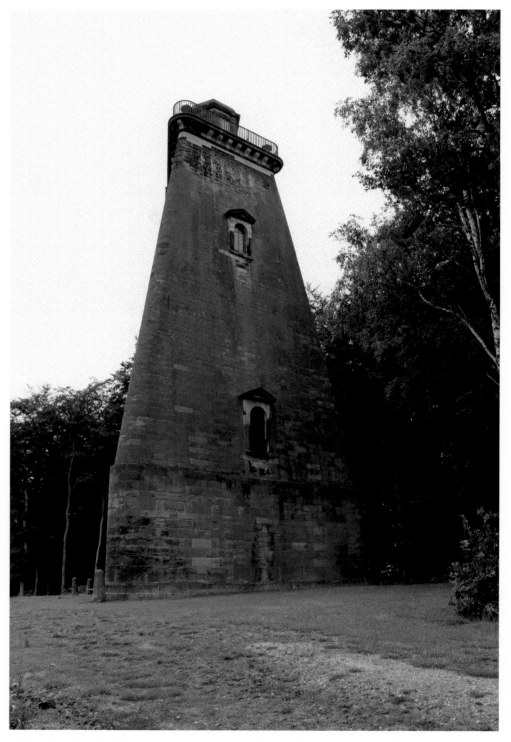

Hoober Stand was built in 1748 to commemorate the end of the Jacobite Rebellion in 1745.

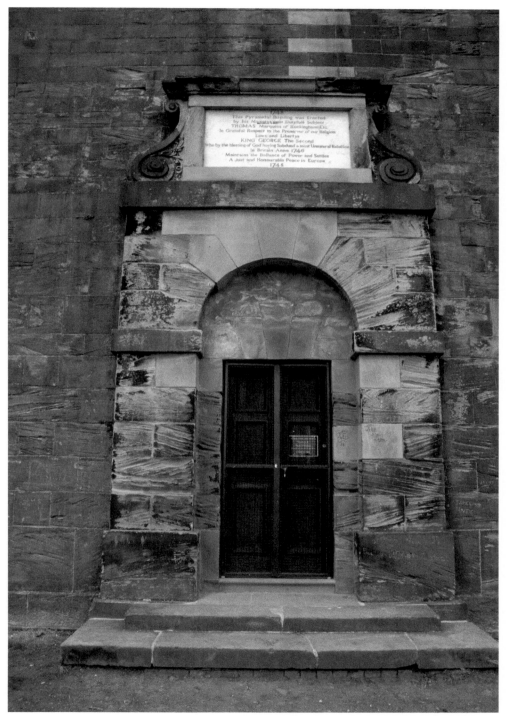

*Above and overleaf above*: The plaque over the doorway to Hoober Stand gives the background of its construction and purpose for its creation.

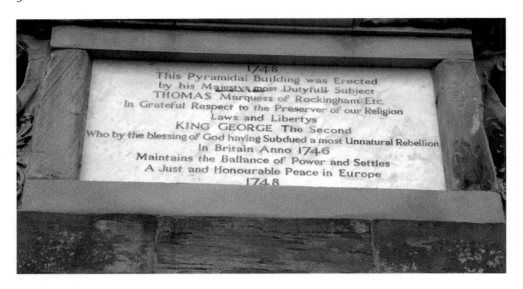

1748
This Pyramidal Building was Erected
by his Majestys most Dutyfull Subject
THOMAS Marquess of Rockingham Etc.
In Grateful Respect to the Preserver of our Religion
Laws and Libertys
KING GEORGE The Second
Who by the blessing of God having Subdued a most Unnatural Rebellion
In Britain Anno 1746
Maintains the Ballance of Power and Settles
A Just and Honourable Peace in Europe
1748

Throughout its history, the Wentworth estate has seen many changes, from an expansive park containing local deer to its current guise as having the largest front entrance of a country house in the United Kingdom.

Holy Trinity Church at Wentworth was also built by the family of the same name. The family's influence in the area cannot be overstated.

The Old Holy Trinity Church at Wentworth, next to the new church, dates back to the fourteenth century.

Wellgate, a popular destination in the town, bears the name of its initial purpose; the centre was home to a widely used well including nearby cattle troughs for any livestock travelling through the area. Maps from 1774 show the location of this well and nearby buildings. The well would have provided a source of water for the population in this area, alongside the main waterspout which was located in Jesus Gate next to the steps of the old Town Hall.

One of the most well-known landmarks near Rotherham town centre was built in the eighteenth century: Boston Castle. This structure was commissioned by the 3rd Earl of Effingham, Thomas Howard, as a symbol of support for the American War of Independence which took place between 1775 and 1783, raging across the Atlantic during this time. The earl had strong opinions regarding the war but did not take any particular side in the conflict. His disagreement with how the war was progressing would lead to him resigning his commission.

Boston Park became Rotherham's first official public park in 1876, encompassing Boston Castle and its grounds. This was closely followed in 1891 by Clifton Park, including Clifton House and its vast swathes of land. Clifton House, modern-day Clifton Park Museum, was built in 1783 and designed by the famous industrialist John Carr of York. The house changed ownership throughout its many years and was converted into a museum in 1893.

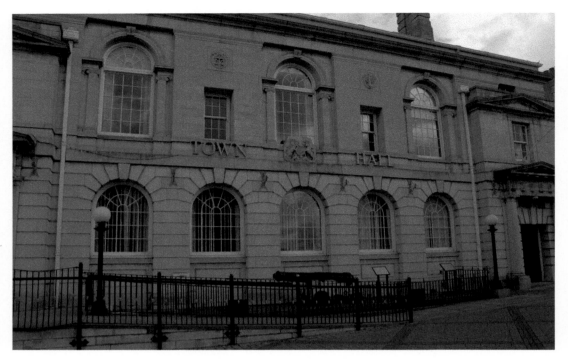

The current Town Hall is in its fourth iteration, most recently moving here during the 1990s. This building was originally the town's courthouse.

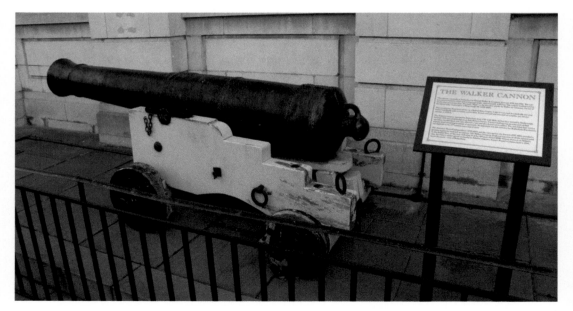

The famous Walker Cannon located outside the Town Hall that was made in the eighteenth century by Samuel Walker & Company. This company was based in Rotherham and had a good reputation for its manufacturing capabilities.

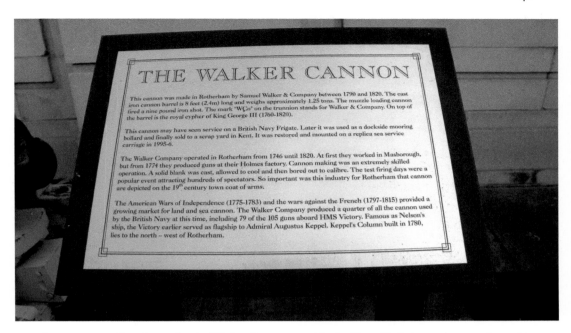

## THE WALKER CANNON

This cannon was made in Rotherham by Samuel Walker & Company between 1790 and 1820. The cast iron cannon barrel is 8 feet (2.4m) long and weighs approximately 1.25 tons. The muzzle loading cannon fired a nine pound iron shot. The mark "WCo" on the trunnion stands for Walker & Company. On top of the barrel is the royal cypher of King George III (1760-1820).

This cannon may have seen service on a British Navy Frigate. Later it was used as a dockside mooring bollard and finally sold to a scrap yard in Kent. It was restored and mounted on a replica sea service carriage in 1995-6.

The Walker Company operated in Rotherham from 1746 until 1820. At first they worked in Masborough, but from 1774 they produced guns at their Holmes factory. Cannon making was an extremely skilled operation. A solid blank was cast, allowed to cool and then bored out to calibre. The test firing days were a popular event attracting hundreds of spectators. So important was this industry for Rotherham that cannon are depicted on the 19th century town coat of arms.

The American Wars of Independence (1775-1783) and the wars against the French (1797-1815) provided a growing market for land and sea cannon. The Walker Company produced a quarter of all the cannon used by the British Navy at this time, including 79 of the 105 guns aboard HMS Victory. Famous as Nelson's ship, the Victory earlier served as flagship to Admiral Augustus Keppel. Keppel's Column built in 1780, lies to the north – west of Rotherham.

A commemorative plaque for the Walker Cannon outside the Town Hall. As can be seen from this information, the cannon was originally used on a Navy ship.

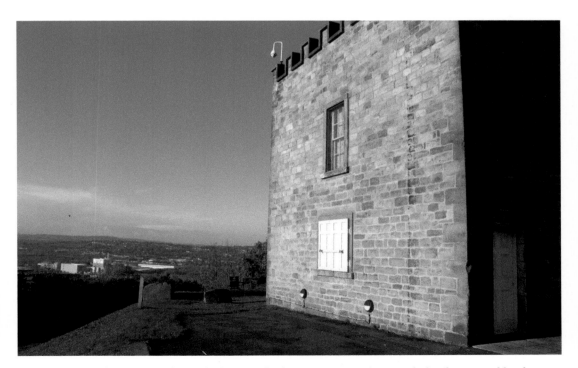

The front of Boston Castle overlooking Rotherham town was a hunting lodge frequented by the Earl of Effingham in 1775.

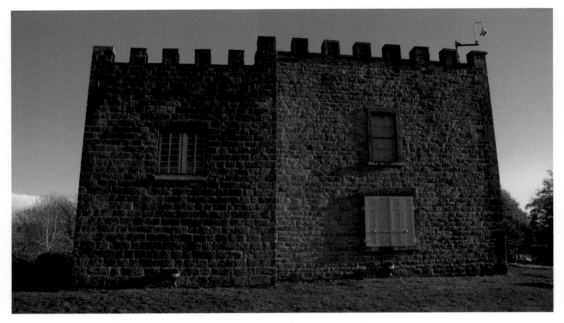

The original stonework of Boston Castle is present even though some areas have been recently repaired. The site is more extensive than it appears from the town.

Boston Castle is home to a mini amphitheatre used for local shows and performances. The castle's name comes from the Boston Tea Party which famously took place in 1773.

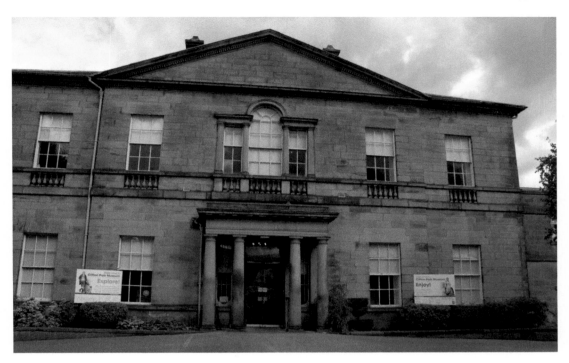

Clifton Park Museum, previously Clifton House, is home to various local history exhibits as well as Rotherham Archives.

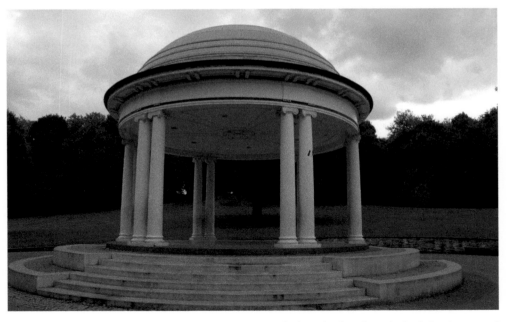

Clifton Park is home to many impressive structures, including this bandstand which has been used by the town since 1928.

Around 1877 the site that was previously the roman fort at Templeborough was excavated after being largely left unused due to its unsuitability for agriculture. The main excavation was done at the behest of the Literary and Scientific Society which no doubt wanted to discover more of the area's secrets and how it connected with the

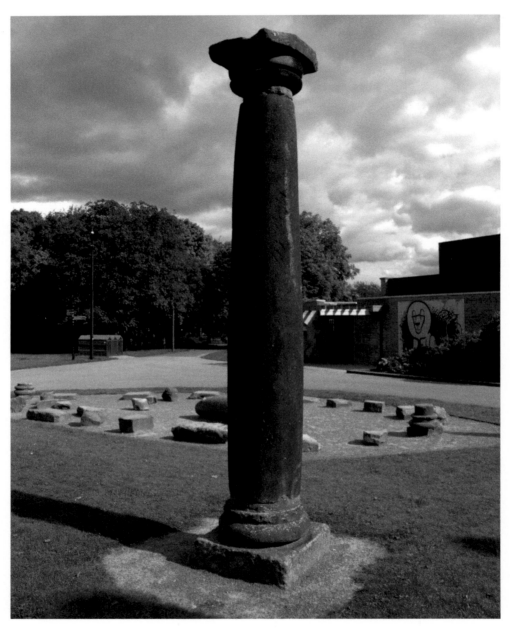

Roman remains from the excavation at Templeborough can be seen in the grounds of Clifton Park Museum.

wider history of Britain. A full and extensive excavation was not completed until 1916 when the industrial giant Steel, Peech and Tozer Ltd acquired the area. Many artifacts were discovered during this excavation period and are currently viewable at Clifton Park Museum. The remains of a Roman granary were dug up and erected in the grounds of the museum and can still be seen today.

As with many towns and cities across the United Kingdom, the eighteenth century saw a surge in technological advancements relating to the industrialisation of various processes. One of the main contributions of the town was the development of the Rotherham Plough in 1729 by a local Eastwood resident called Joseph Foljambe. The restructured design provided a more efficient way of using the plough, including giving it the ability to be pulled by only two horses.

This period in the town's history was difficult for its inhabitants due to the high levels of poverty, but there were still instances of recreation and fun. One notable example was the commission of a large bonfire in 1707 to celebrate the recently announced union of England and Scotland, forming the beginnings of what we now see today as the United Kingdom. It must have been an amazing event to attend and there is no doubt that the people who joined in would have remembered the event fondly for many years to come.

Rotherham has been the home of many famous authors including one of the most influential of his time: Ebenezer Elliot. He is more famously known as the Corn Law Rhymer due to his fight against the controversial Corn Laws of the time. His famous collection of poems was released around 1815 and extensively covered this topic. The name has most recently been used for a popular pub located at the top of High Street, although at the time of writing this has unfortunately closed.

One of the most famous companies set up in Rotherham was established in 1833 and named The Rotherham Gas Light and Coke Company, located on the riverbank north of Rotherham bridge. This gasworks provided the local area with power as well as a source of employment. Other industries flourished throughout the nineteenth century with the establishment of companies that would become famous across the country, including George Wright and Co. which manufactured items for railway businesses such as wheels for the trains. The brass industry was also well established and included companies such as Guest & Chrimes which manufactured fire hydrants used in New York City. During the Golden Jubilee of Queen Victoria in 1887, many new developments took place in the town, including the opening of a new public library and also the completion of the School of Art which would be a precursor to the modern-day Rotherham College.

Before the advent of road signage, milestones were placed across the town informing road users of the distances to nearby villages or neighbouring towns. They can look out and are very noticeable as they are painted in white with black lettering. Examples of these can still be seen across the borough, including on West Bawtry Road and near Ulley Country Park. Many have been well maintained and provide a small glimpse into the past of Rotherham's road network.

During the eighteenth century travel by coach became more popular, especially among the richer members of the town. This created various jobs, including the creation of new coach companies and the opening of many coach inns to provide a place for travellers

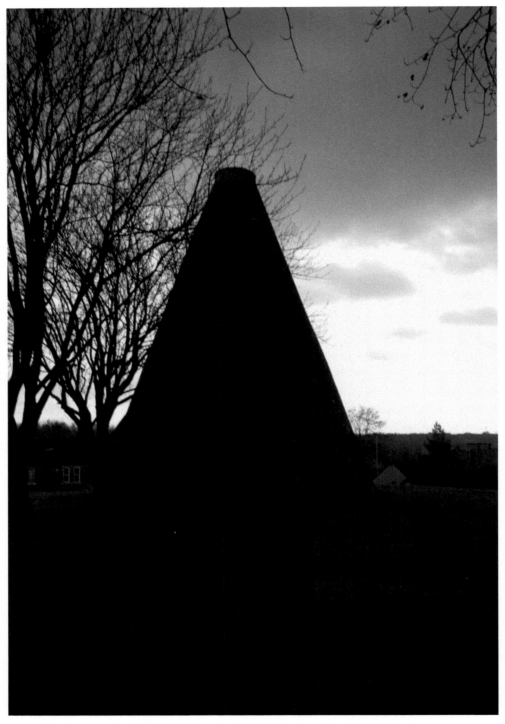

Silhouette of the Catcliffe Glass Kiln, known locally as the Catcliffe Cone. Glass working was an important industry in Rotherham. The structure was built in 1740 and is a Grade I listed building.

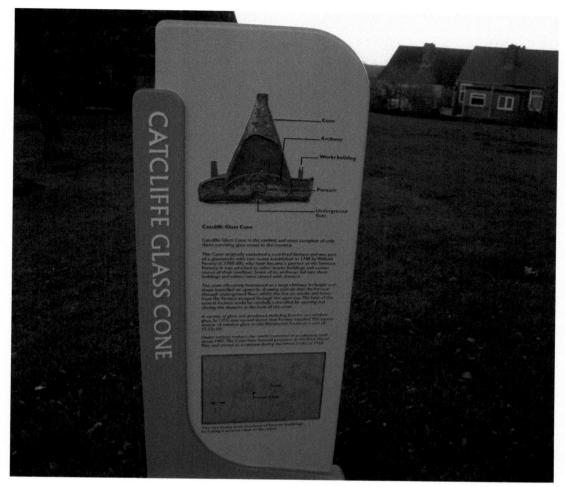

The history of Catcliffe Glass Kiln is varied and can be seen on this information board at the site.

to rest on long journeys. The main coach inn in Rotherham during this time was The Crown on High Street which provided a central place for all visitors to stay in the area. During 1787 main transport routes stopped at The Crown on their journeys, such as the trip from Sheffield to Doncaster. The trip from Rotherham to Doncaster would have cost 4s in the early nineteenth century and would have taken a considerable amount of time, demonstrating how important inns would have been to travellers on long journeys during this time. The remnants of The Crown, established before the seventeenth century, still remain on High Street, although as of writing this book the building is closed to the public. The nineteenth century saw transportation by coach expand further to include even more services, for example, in 1829 you could take a coach from the Crown Inn to Doncaster every morning at 8.30 a.m. and 12 noon.

Education during this time was not as regulated as it would be in later years, and children who were poor often struggled to receive any sort of formal schooling. To

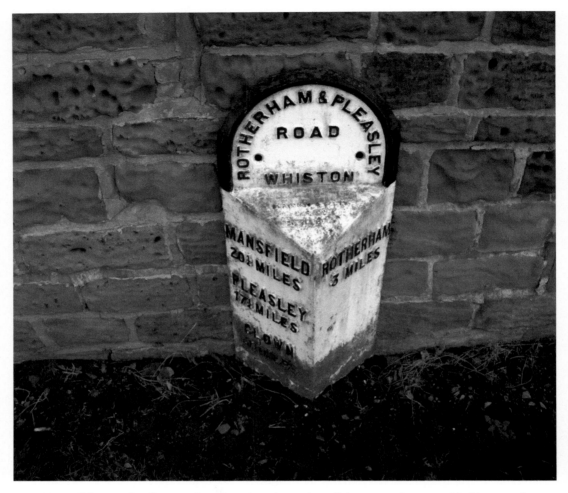

Many of the town's milestones have been kept in good condition, as can be seen with this example near Whiston.

help change this the Feoffees in Rotherham, with influence from Thomas Rotherham, set up a charity school in 1708 to help children who were not already destined for the grammar school which had existed in the town since the fifteenth century. One of the main benefactors who donated money was Thomas Wentworth, who gave £136 to help purchase land for the school. A total of around £281 was raised for the school, a vast sum of money for the time, which helped to set the foundations for what would become one of Rotherham's first large schools for the working class designed to help local children to learn to read and write as well as do basic arithmetic. Documents still exist for how the school was run, including the times that the school was open. This consisted of summer opening times of 7 a.m. and closing at 5 p.m., and winter opening times of 8 a.m. and closing slightly earlier at 4 p.m. due to the lack of daylight. The school was affectionately known as the bluecoat school in 1775 due to the blue uniform worn by the children who attended.

During the late nineteenth century Rotherham had established four main schools where education was provided to the population: the Feoffees School, Hollins school, Grammar school and a fourth private school for paying customers. The district school board of Rotherham decided to expand the education provision further, opening many local schools in areas such as Wellgate in 1879, Kimberworth in 1900 and also Brinsworth in 1901. This provided an opportunity for more of the town's children to access basic education from an early age which previously may not have been possible due to the distance between schools.

Like many towns and cities throughout the country, the workhouse was a source of dread and fear among the local population. The year 1834 saw the Poor Law in the UK being updated, grouping local parishes into Poor Law Unions. The main purpose was to provide support to the most vulnerable in society. Help would be available from the local government if the resident agreed to be admitted to the local workhouse. The area it covered ran from Wath in the north down to Aston in the south. The main workhouse in the town was constructed in 1839 and could house up to 300 inmates at any one time. On admittance men and women were separated, with the children being housed in the women's wing. The first hospital in the town, Doncaster Gate Hospital, was not built until 1872, so before this the poor of the town had to use the workhouse to access any medical care. These institutions were set up to assist the poor by providing them with a place to stay, food and meaningful work. In reality many of these places were not much better than a prison, not providing adequate meals or places to sleep. It was very difficult for anyone to leave the workhouse once admitted and for most, it became a life sentence. Rotherham's workhouse moved locations throughout its history but its most well-known and established location was at Alma Road. The workhouse finally closed its doors in 1929 after becoming the Rotherham Public Assistance Institution.

The nineteenth century saw the introduction of street lighting in the main areas of the town centre. Oil lamps were strategically placed to provide increased lighting in areas of the town that people used frequently. Lamps were only lit during specific times of the year and in certain conditions, such as during winter and when there was not a full moon visible. One of the stone pillars of an oil lamp post can still be seen in Wellgate.

This century also saw the introduction of new amenities in the town after local businesses decided to work together to provide the populace with what were fast becoming basic necessities. This included a privately run water company first set up during 1827 which was located on Quarry Hill in Wellgate. It consisted of a large steam engine pumping water from the local spring, eventually being plumbed into residents' houses, who paid for the privilege. The water supply at this time was sporadic and did not provide a regular flow for people to use, but was still an innovative practice at this time. This facility would have been expensive and was only reserved for the wealthy members of the town.

The first signs of a local medical facility were seen in 1806 when a dispensary was opened, and this eventually found a permanent home in the town. As there was no hospital in Rotherham anyone at this time who was severely ill or injured had to make the journey to the infirmary based in Sheffield, a journey that would have been well over 10 miles for many Rotherham residents.

Housing demand increased during the nineteenth century, partly due to population growth and also because of the many new industries in the town. The town had much of its green space still available at this time, so this was used to start building housing stock. With more houses came more pressure for the local government to provide suitable living standards. At this time there was no established water or sewerage system, which would have impacted greatly on the town. Records show there was a high mortality rate in 1850: approximately one in thirty-seven inhabitants were dying from many diseases including fever from illness and dysentery, caused by a lack of hygiene and washing facilities. There were many outbreaks of disease, including a cholera outbreak in 1832 that killed thirty-one people. Medical facilities were lacking in the town, so the affected would have had to endure this disease without any hospital attention. A burial ground specifically for people who died from cholera was set up and can be found today at the Pump Road burial ground.

The lack of a hospital caused outrage amongst local residents and a petition was sent to the government in 1850 explaining the unliveable conditions in the town. The government responded by setting up a public enquiry which found evidence of these claims, including a lack of water for over 50 per cent of the population and raw sewage leaking into local wells. A local Board of Health was set up to manage the situation and coordinate efforts to help with the town's sanitation problem.

Moorgate Cemetery also houses many graves of cholera victims and was constructed to create more burial space due to the amount of people that had died.

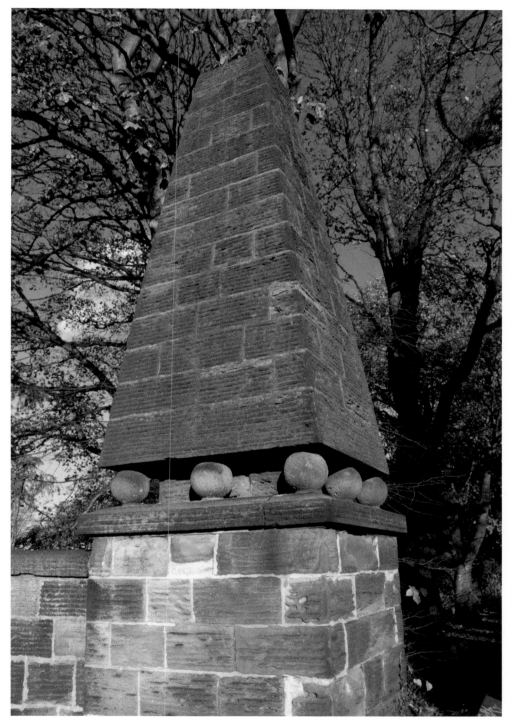

A pillar outside Moorgate Cemetery. Even something as commonplace as this pillar shows some interesting design choices.

The first publicly accessible railway in Rotherham was opened in 1838 by the Sheffield and Rotherham Railway Company. The first line connected Westgate in Rotherham to the Wicker area in Sheffield, providing a quick mode of travel between the two populous areas. This line was further extended to become part of the Midland Railway in 1840, connecting the town to places even further afield. Initial railways were built to connect local collieries to each other, but this quickly developed into a commercial enterprise open to the public.

Transport did not always have a positive effect on the town, which can be seen in the tragic Masbrough Barge Disaster in 1841. Events such as the launching of new barges would have brought a large crowd of local spectators who would have taken the opportunity to meet friends and take their children out for the day. The barge in question was designated to have a dry dock launch – in effect launching it down a short incline into the river after the major structure of the vessel had been completed. Before the launch members of the crowd, including many children, climbed onto the vessel. Unfortunately, the barge tipped over, causing catastrophic damage and the deaths of around fifty people.

Rotherham was home to many impressive cultural buildings which put on a variety of entertainment for the townsfolk. Some of the more well-known establishments included the Theatre Royal built on Effingham Street in 1873, the Empire Theatre at the top of High Street, opened in 1913 and known for showing films, and also the Hippodrome located on Henry Street, having a capacity for around 2,500 visitors. The first official picture house in the town exclusively for showing movies was the Picture Palace located on High Street, which was opened in February 1911. This establishment would stay open for many years and was eventually renamed the Whitehall Cinema. Other picture houses would open in the early twentieth century and become well known throughout the town, such as the Premier Picture Palace opened in 1912 on Kimberworth Road, and the Tivoli opened in 1913 on Masbrough Street.

During the nineteenth century timekeeping had become increasingly important for the population. Unfortunately, clocks at the time were extremely expensive and it was not an item that the majority of the town's residents could afford. As an alternative, Rotherham Minster rang its bell at 5 a.m., 12 noon and 8 p.m. during the summertime and 6 a.m., 12 noon and 6 p.m. during the winter months. It would be expected that many other churches in the area would have had a similar arrangement.

Rotherham began a wave of church building to help meet the religious needs of the people. Some of the most notable examples include St Stephen's at Eastwood constructed in 1874, St Andrew's at Brinsworth built in 1885, and St James' in Clifton which was completed in 1887. Other places of worship were also built due to various splits in the religious denominations, such as Chapels which can still be seen to this day. Other places of worship have now been repurposed, such as the Rotherham Congregational Church being changed into Rotherham Civic Theatre, which opened in the 1960s.

An example of one of the boroughs' impressive churches can be seen in Laughton-en-le-Morthen which is home to two churches; one is the All Saints Church and is well known due to it being over 185 feet tall. The village is also home to a smaller, lesser-known church at the other end of the village. The village itself dates back to the eleventh century and as mentioned previously, has the remnants of an old castle.

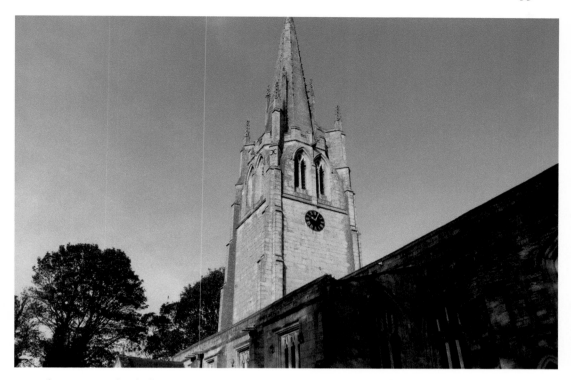

The main steeple of All Saints in the village of Laughton-en-le-Morthen raises up to 185 feet and can be seen from many of the neighbouring villages.

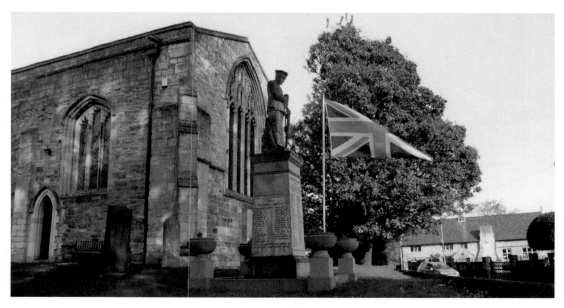

In the grounds of the church is a war memorial to fallen soldiers. The impressive stone structure of the church has been preserved well over the centuries.

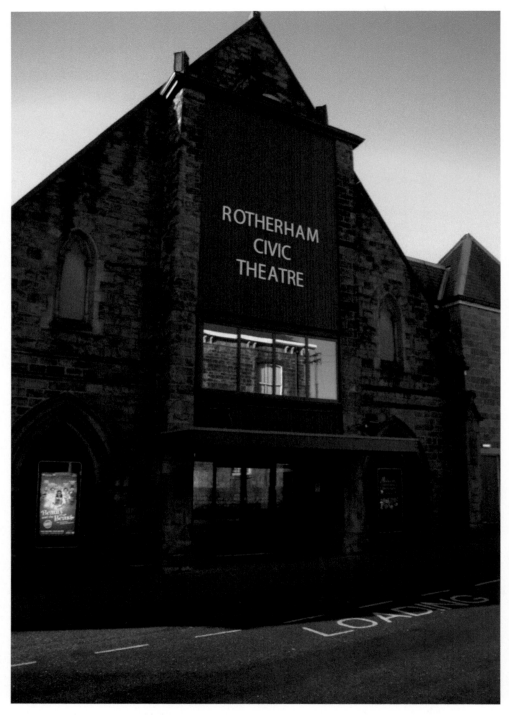

Rotherham Civic Theatre is still a popular destination for many residents in the town and provides a place for local actors to ply their trade. Famous local acts to perform here include the Chuckle Brothers.

Another major technological introduction at the start of the twentieth century was the construction of an electric tram system covering busy areas of the town such as Sheffield Road and Effingham Street. This was made possible in 1900 by the Rotherham Corporation Act and helped pave the way for modernisation of the town's transport network. Laying of the tracks and preparation of the existing roads began in 1902. This system was expanded to also include trolleybuses, which were in effect similar to regular buses but needing a constant electrical connection to the overhead wires very similar to how a tram operates. By 1912 Rotherham was the first major town in the United Kingdom to operate extensive trolleybus coverage outside its main town area – in this instance to Maltby. This helped Rotherham to consolidate as a borough of townships which had begun in 1871, bringing together all surrounding villages into one main area, with its first mayor being John Matthew Habeshon.

One of Rotherham's most recognisable town centre landmarks is the Imperial Buildings which were first opened in 1908. These buildings are still open today and include a local bar and vegan takeaway.

The Imperial buildings are Grade II listed and were built in the early twentieth century.

# Coal, Steel and Sweat (1900–1990)

This period in history was one of the most innovative in Rotherham as collieries and steelworks became the norm throughout the north of England. By the twentieth century mining was well established in the Rotherham area, with the combined workforce mining hundreds of tonnes of coal each year. The mining and steel industries were the keystone for many new communities that grew up around factory and colliery sites, providing employment for the local population over many generations in well-known companies such as the Phoenix Bessemer Steelworks, opened in 1871. It would become a tradition in Rotherham, like many other mining communities, that sons would follow their fathers into the mining or steel profession, creating a strong sense of pride tied to these specific industries. Advancements in coal mining technology allowed more coal to be brought to the surface and with it the boom of industry across the region, ranging from steel mills to the local railway companies, meant there were ample job opportunities for local people. Even during the twentieth century it was known that you could leave one job on a Friday and be employed again by the Monday.

The steel industry played a vital role for the people of Rotherham. Alongside the city of Sheffield the town became a major player in the United Kingdom, manufacturing a variety of items to be shipped across the world. One of the main companies set up in the town was the Park Gate Iron and Steel Company established in 1823. The company continued to grow and had a major expansion implemented in the 1960s investing approximately 32 million pounds. The expansion included new Kaldo Oxygen Steelmaking units as well as a new plant that included electric arc melting furnaces weighing around 75 tons. Due to the high demand for steel and the company's good reputation, this investment was necessary for continued expansion and allowed the steelworks, consisting of over 1,000 men, to output 800,00 ingot tons a year.

As mentioned previously, mining was a major source of employment in the town. The main coal seam present in the area was the Barnsley seam and was one of the only seams actively worked during the Victorian period, until further expansion of the industry opened up new areas to be exploited. Working conditions were poor and safety often an afterthought when weighed against the potential profit that the pit owners could make. To put this in perspective, records at the time showed an average of 8,000 deaths caused by pit accidents during this period across the United Kingdom. In South Yorkshire approximately four miners died each day and around 500 were injured between the late nineteenth century and early twentieth century. Even as safety started to improve, fatalities were inevitable, with a recorded 125 deaths between the years 1866 to 1994.

The main dangers at the time were underground explosions caused by collected gas (also known as firedamp) and faulty unregulated mining lamps, tunnel collapse and accidental mistakes when using certain machinery. The sheer number of disasters during

the nineteenth century resulted in the 1842 Mines & Collieries Act being introduced, bringing in measures such as women and children under the age of ten being barred from working underground. Legislation was slow to enshrine miners' safety and it wasn't until the 1911 Coal Mines Act that further measures were introduced. Relief for families, such as money towards funeral costs for people who had died in the mine after these disasters, was sporadic and mainly relied on the good nature of the individual pit owners. As a result, the South Yorkshire Miners Association was set up.

Pit rescue at this time was not well organised and local pits relied on the support of neighbouring collieries to send men and resources when disaster struck. Any recommendations to improve safety after a disaster, including how better to organise pit rescues, were rarely followed through by pit management. News of disasters spread quickly across the United Kingdom, hyped up by national newspapers, and wealthy people were known to make trips to come and visit recent disaster areas (Charles Dickens visited a mining disaster in Barnsley and wrote of his experience there).

The following record of mining disasters in the Rotherham area will ensure that these tragedies, and the men involved in them, will not be forgotten and future generations will be able to appreciate how dangerous the mining industry was at this time in history.

The first notable Rotherham mining disaster of the nineteenth century was at Warren Vale Colliery near Rawmarsh. The mine consisted of two main mine shafts and was sunk in 1850. The disaster occurred on 20 December 1851, just before 7 a.m., when an explosion rocketed up one of the shafts and blasted off the main headgear. Witnesses at the time stated they could hear it over 3 miles away in neighbouring villages. The disaster caused the deaths of fifty-two of the sixty-three workers on site at the time, and left many mutilated. Rescuers came from nearby collieries, some owned by the famous local landowner Earl Fitzwilliam, although it was stated that gas was still a hazard for many of the rescuers. The deceased miners were taken to their homes to be temporarily laid to rest, or if this was not possible, they were taken to the local Star Inn. The cause of the disaster seemed to be related to firedamp released after a roof caved in and was ignited by a candle. The pit owners were deemed fully responsible, especially due to the fact that there were only two Davy lamps available for the full working shift causing many to use candles, which was extremely dangerous. Many of the graves still exist in Rawmarsh Church as a tragic reminder of this day.

In a stroke of bad luck, Warren Vale Colliery would be the scene of a second major disaster on 20 November 1874. This was also caused by an explosion in the Barnsley seam during the early morning, very similar to the first disaster, and was also thought to be the result of a roof collapse. Candles were also being used at this point still, mainly because they provided better light than the Davy lamps that were in circulation. Light was an important asset for a miner, as they were paid by how much coal they mined (better light meant better productivity and in the end higher wages). This disaster caused twenty-three deaths and shows how safety recommendations were not always followed through, even after a similar disaster at the same colliery only a few decades earlier.

The next major disaster took place at Aldwarke Main on 5 January 1875 a few weeks after the second Warren Vale explosion. Unfortunately this was also an explosion caused by the use of a candle. Aldwarke was in essence a combination of two separate underground

workings as it was joined underground with Carr House Colliery. The explosion began in the Carr House tunnels at around 6 a.m. and caused the deaths of seven miners. As with the previous mentioned disasters, gas build-up was a major issue (in this case it was afterdamp) for the rescuers who entered the mine. Analysis of the disaster brought to light bad record keeping by pit management, which would have contributed to the overall ineffectiveness of safety at the mine. As was common during the time, a ruling of accidental death was given.

As was similar for Warren Vale, Aldwarke pit would not be spared from another disaster, as shortly after the above explosion there was a tragic winding accident on 23 February 1904 causing the deaths of seven workers. It was around 5 a.m. when a winding rope snapped before the cage containing the miners could safely stop. It dropped 80 yards and crashed into the bottom of the mine shaft, causing injuries that were either immediately fatal or impossible to treat at the precursor to Rotherham General Hospital, which would not be opened until 1914. The only survivor of the disaster, Arthur Ramsden, was permanently crippled, which affected him for the rest of his life. A third disaster would take place at this location on 16 June 1913 after there was a sudden flooding incident at around 8 p.m. which caused the deaths of eight miners in the Parkgate seam. It was noted at the time that the older mine workings had potential flooding issues and demonstrates how issues were normally ignored leading to disastrous conclusions. This incident is also notable as witness accounts state that blackdamp was present above the waterline in the mine, most likely appearing as a dark sooty mist.

The next major incident took place at Maltby Main on 28 July 1923. The mine was in its infancy during this time after being sunk in 1908 to work the Barnsley seam. Before the fateful day there had been numerous issues reported down the pit, including small explosions and potential fire problems. The conditions became so bad that 122 volunteers had to be formed to descend into the mine. At around 9.15 a.m. a large explosion occurred due to residual firedamp, causing the collapse of many mine tunnels. The disaster caused twenty-seven deaths and the pit management was criticised for letting the volunteers down a mine which they had already deemed to be unsafe.

Kilnhurst Colliery is the next area we visit, previously known as Thrybergh Hall Colliery in its early years and colloquially known as 'Bobs oyle'. It was witness to a disaster on 28 July 1937. At 2.45 p.m. a cage winding incident occurred after one of the cages became uncontrollable by the winder, causing it to smash into the headgear and the second cage to plummet to the bottom of the shaft. Fortunately, only one miner died; however seventeen others would have life-changing injuries caused by the momentary error of the man operating the winding cage. The total length of the shaft was 660 yards but due to good fortune the incident only occurred during the final 60 yards; otherwise, the death toll would have been much higher.

As seen in the previous examples, explosions were a regular danger in the mining industry, and this was proved to be true yet again on 24 June 1941 at Kiveton Park Colliery. The accident occurred in the Barnsley seam, one of the two seams being worked at the time. It was stated that gas was the cause of this explosion, causing the injury of a pit pony and the deaths of five miners due to severe burns.

By the twentieth century there were over eight collieries in the Rotherham area, ranging from large-scale deep-cast collieries such as Wath Main to small-scale drift mines such as

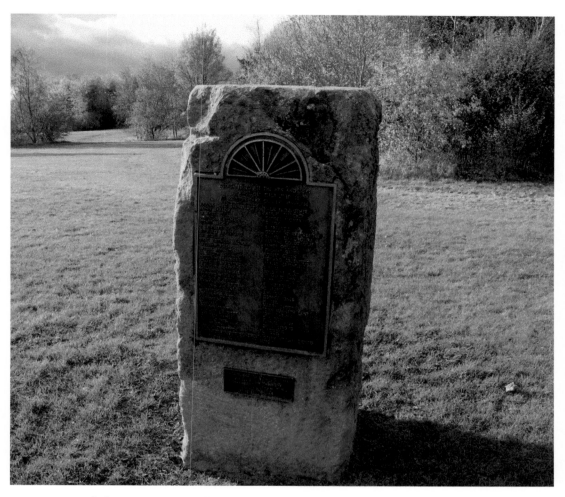

A memorial plaque at Kiveton Colliery in memory of all miners who lost their lives during the pit's operation.

Grange Colliery near the present-day Dropping Well pub. Luckily the Rotherham area avoided any other major disasters until 1966 at Silverwood Colliery, previously known as Dalton Main in Thrybergh, (although death and injuries were still a daily experience at many of the local collieries). The disaster at Silverwood was different to many of the others mentioned previously as it was caused by a paddy mail accident. A paddy mail was a small railway locomotive that transported men and sometimes equipment from the lift shaft to wherever the coal face was located. The disaster occurred when the diesel-powered paddy mail collided with a supply vehicle underground. There were ten deaths in total and thirty-one miners experienced life-changing injuries. Local halls were used as mining rehabilitation centres when required to help miners with a variety of ailments, such as ones caused by the events mentioned above, one of which was in Firbeck Hall. This hall is notable for a few reasons, including being occupied by Royalist sympathisers during

A metal structure showing a pit pony and a coal wagon. Without these reminders dotted around Kiveton Park pit top many people would not realise that they walk on the site of a former colliery.

the English Civil War and being a popular haunt for Edward VIII when he was Prince of Wales before his abdication.

As can be seen from these many examples, mining was a hazardous occupation. Particularly during the early days, pit owners seemed more concerned with profit over the well-being of their staff. The hardiness bred into miners would provide them with the tough resolve needed to cope with the many strikes they had to undertake due to harsh working conditions, ultimately culminating in the 1984/85 miners' strike which would be the beginning of the end of mining in Britain. This will be covered later in this book.

The First and Second World Wars had a major impact on Rotherham's community as many men between the ages of eighteen and forty-two were sent to fight abroad. There was a list of reserved occupations set out by the government that excluded certain professions in protected industries needed for the war effort, such as the steel and coal mining industries.

During the First World War local territorial armies, known as the Territorial Force between 1908 and 1921, were set up and mobilised for the war effort, including in Rotherham. This included the York and Lancaster Regiment 6th Battalion that was formed in September 1914 to take on any civilian volunteers for the war effort. Over 800 men enlisted, which meant that a 7th Battalion had to be formed. By the end of the war in 1918 around twenty-two battalions had been set up consisting of the brave men

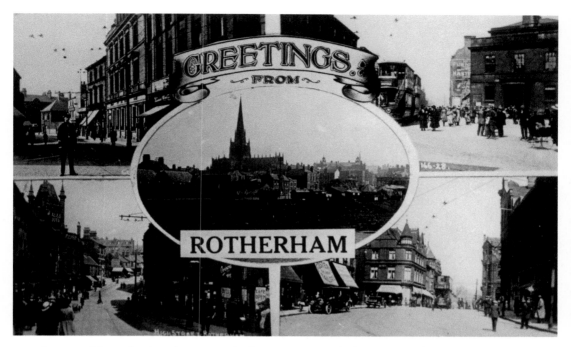

A postcard from the time showing Rotherham as it was in the late nineteenth and early twentieth century. High Street can be seen and shows the same layout as today. Trams, seen in the image, were the primary mode of transport around the town during this time. (Thank you to Rotherham Archives for the use of the picture)

from the town and local areas. These men would see service across all theatres of war between 1914 and 1918, including Egypt, France and Italy. During this time *The Rotherham Advertiser* helped to keep the town updated with what was happening, including sharing heartbreaking stories from family members desperately searching for information on their missing loved ones who had gone to fight overseas. Patriotism was high in the town, and many established businesses began to manufacture items for the war effort, for example, Owen & Dyson went from producing railway wheels to shells and ammunition.

Clifton Park was a notable location used for training soldiers during this period, such as the 164th Rotherham Howitzer Brigade. Oakwood Hall, originally built in 1856 by local steel baron James Yates, was also repurposed into a military hospital in 1916 for any wounded that were returning to the area. Oakwood Hall has recently been used by Rotherham District General Hospital for storing records.

The royal family made many visits to factories across the UK during the First World War to help boost morale amongst workers producing munitions for the war effort. Royalty visited the manufacturing plant of Steel, Peech and Tozer during October 1915. Although there was not as much civilian bombing during the First World War as would be seen in later conflicts, there was a sizable raid in 1917 on the Parkgate Steelworks. Luckily only minor damage was caused by the attack, and it would have only served to embolden the local population to work hard for the war effort. The remnants of a 200-pound Zeppelin bomb were unearthed in Templeborough during extensive excavations in 1961.

A bench of remembrance recently set up outside Rotherham Town Hall. Ship Hill is in the background as well as the well-known High House pub that has been open since the nineteenth century.

As mentioned earlier, this area was the site of heavy workings due to its connection to past Roman activities, and this find must have certainly shocked the dig team normally used to excavating old buildings and tools. During the last year of the conflict a final deadly blow would hit the town in the form of an influenza outbreak referred to as the 'Spanish Flu', ravaging the already tired cities and townsfolk throughout the country. Rotherham was not spared this misery and there was a recorded death toll of 294 residents.

The First Word War had a major impact on Rotherham and its people. To commemorate this event the impressive Clifton War Memorial was commissioned, and it was officially unveiled on 26 November 1922. A total of 1,304 names of men who had lost their lives were inscribed on the monument. It is still in use today and the names of Rotherham residents who have given their lives in more recent conflicts have been added.

The introduction of council housing in the early twentieth century gave many poor UK residents the chance to acquire affordable housing owned by the local council. Rotherham also adopted this strategy, and the first council housing developments were built in East Dene in 1924. The development of new housing areas for existing residents began with a programme of slum removal. Any areas identified as such were designated to be removed and their occupants rehomed in newly developed areas. This process began in around 1934 and included eleven clearance orders covering 258 homes. The clearance of these areas carried on for well over the next decade, and by the year 1930 a total of 1,196 houses had been destroyed.

The Clifton Park War Memorial is an impressive site and is set amongst a garden of reflection.

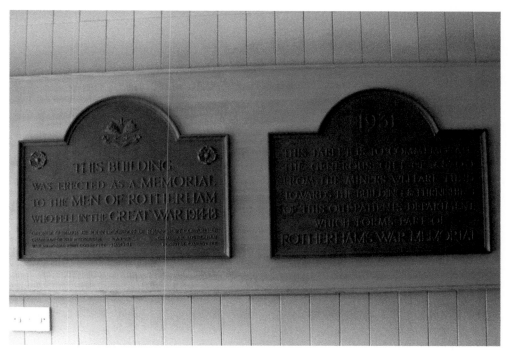

One of the many war memorial plaques dotted around Rotherham commemorating this historic event.

Housing is still a priority for Rotherham Council and innovative developments have taken place to make use of the space available; for example, Beeversleigh flats were constructed in the late 1960s and are a well-known landmark due to its interesting design.

Despite the above actions, houses in central Rotherham during the 1930s were classed as cramped and lacking space, especially for families living in poverty. It was normal for multiple generations of families, including extended family such as cousins, to live in the same household and be brought up together. Freshly baked bread would have been commonplace and a main staple of the family unit. It was known that rugs throughout the house would be repurposed as blankets for night-time use. For extra warmth winter coats were also used as blankets, especially during winter. Bricks would have been warmed up on the fire, then wrapped in blankets or sacks and placed in the bed to provide a comfortable temperature for sleeping.

Men of the family would mainly have been involved in coal mining or steel working, whereas women would be homemakers as well as earning extra income doing various jobs, for example picking potatoes in the local farmers' fields. Children of the household would be in general education until the age of fourteen, at which point they would be expected to start full-time work, in industries such as those previously mentioned. It was common for younger children to go and buy their parents' tobacco from the local grocery shop or go and visit a local pub to fill up a jug of ale as the law on the sale of these items to children did not come in until the last part of the century.

An example of housing typical in Rotherham would have been the stone cottages located near Bradgate opposite the Effingham Arms, although these have now been demolished to make way for other buildings. The grammar school was out of reach for the majority of working-class children who were expected to contribute to the family income due to the hardships most families experienced, although some did attend further education, eventually moving into different professions. Going to a university was almost unheard of for most young adults during this time due to the cost of tuition and class discrimination that would have been present.

Post-First World War, British industry started to boom. In Rotherham, new businesses such as the United Steel Companies Ltd (which also included Rother Vale Collieries Ltd) developed. However, even with this boom, unemployment reached critical levels during the post-war period, causing a lot of civil unrest amongst the population, who were struggling to live day to day. Unhappiness culminated in organised strikes, notably the Miners' General Strike in 1926. Rotherham miners took part in the nine days of strike action which started on 3 May of that year.

The Second World War saw Rotherham exhibit the same town spirit and patriotism as shown in the first global conflict. As men were called up to fight, women of the town began to work in occupations not usually open to them, such as heavy industry and in military roles such as Bomber Command located near Bawtry. Certain companies in Rotherham continued to make raw materials vital for the war effort, which meant that their employees were in a reserved occupation and could not be conscripted to fight in the war.

Home guard units were set up during the Second World War and were popular among the older generations in Rotherham who wanted to contribute to the war effort. One of the main headquarters for the town was at the Stag roundabout. The location is now The Stag public house and still shows writing on the side of the building hinting at its past use. Even though many of the men were only armed with wooden weapons designed as a deterrent, they showed a steely resolve, and the community revered these brave men and women. Children would play with these weapons as part of their games, as well as swinging on the anti-bomber balloon tethers in Bradgate Park. Other volunteer jobs included air-raid wardens who would patrol at night when it was reported bombers were overhead to ensure that all unnecessary lights were turned off, including curtains being drawn, to prevent the German pilots from finding the town. Many stories from the time period show how the town pulled together and helped each other during this dark time.

Workers' rights had become a major issue in the mining industry as the twentieth century came to a close, largely as a result of extremely difficult working conditions and abuse by pit management. This would all lead to the miners' strike of 1984/85. The strike itself is a complex topic, and the following section will focus on the impact it had on the Rotherham area, including any major events that took place during this time.

At the time of the strike the UK coal industry employed around 180,000 miners across its many collieries including over fifty-six pits in Yorkshire. The initial start of the strike was related to miners at Cortonwood Colliery near Brampton Bierlow who were disputing the amount of break time they were entitled to after management had tried to reduce it.

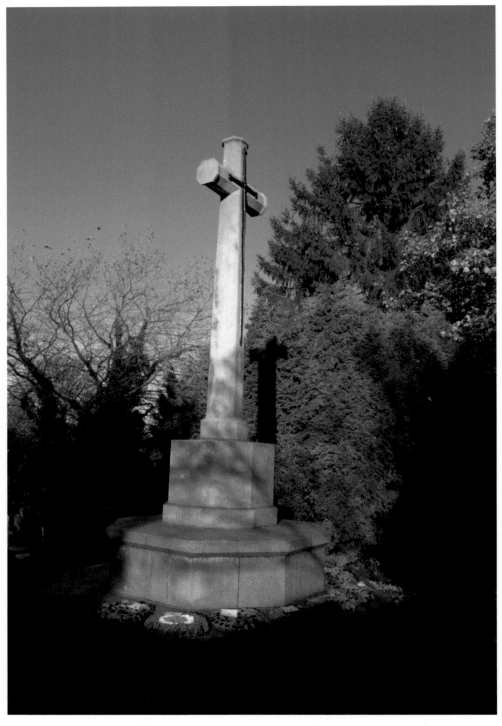

War memorial sites are present throughout the town, this particular one being located within Moorgate Cemetery.

The first sign of strike action in the Rotherham area was at Manvers Main in March 1984 when the workers staged a walkout. A notable battle in Rotherham took place at Cortonwood Colliery near Brampton Bierlow, where police chased men away from the picket line, causing some to use the nearby canal as a route to safety. Workers had been notified by the government that the pit would be closed within five weeks, the first of twenty planned pit closures across the UK in 1984, causing the loss of 20,000 jobs. Simple economics was offered as the reason, but it was widely believed by the miners that the reason was more strategic: the government wanted to reduce the influence of the National Union of Miners (NUM) by reducing the number of open coal mines. They would be vindicated in 2014, when previously unreleased cabinet papers relating to the strike revealed a plan to enact an intentional nationwide closure of collieries. The report included information about extra police training in the lead-up to the strikes, increased recruitment of police officers and substantial pay rises, most likely as an incentive for what was to come. The government also stockpiled coal as if in anticipation of the widespread pit strikes that would follow. Some also speculated that Cortonwood was a way for the government to test the waters as its union was considered less militant than some others.

The striking miners at Cortonwood created a refuge called 'The Alamo', a hut constructed to act as a point of contact for the miners on the picket line. Many collieries across Rotherham would create similar sanctuaries for the striking miners to use as a base and point of refuge during the long hours of picketing and between the various clashes with police. From pictures of the time, it seems that these were mainly of a wooden construction, easily destroyed but also easily rebuilt and moved when needed. Those who wished to cross the picket line and continue to work, known as scabs, required police escorts. Some are still ostracised in their communities to this day.

Numerous collieries in the area were involved in organised 'flying pickets', a term used to describe groups of striking miners who would travel to other pits in the country to join their picket lines and help push back the police. When the police became aware of this innovation, travel between counties became increasingly difficult, especially for vehicles full of young men. Police tactics at the time included bringing police forces from elsewhere, who were expected to be more ruthless with the local miners due to the fact they did not know them. Some police officers were tasked with quickly grabbing ringleaders at picket lines to try and reduce the morale of the strikers. Such officers became widely known as the 'snatch squad'. Picket lines extended further afield than the local pit entrance, as demonstrated when groups of pickets brought traffic to a standstill on the M180 near Scunthorpe.

Despite their confidence, the government and the police underestimated the resolve of the miners, and frustrations would come to a head in Rotherham at the widely known Battle of Orgreave. A small village on the outskirts of Rotherham, Orgreave is around fifteen-minute drive from the town centre. At the time it was home to a large industrial complex known as Orgreave Coking Plant, or Orgreave Coke and Chemicals, whose main role was to process and provide coal suited to the local steel plants. Initial pickets arriving at the Orgreave site attempted to prevent haulage trucks from transporting coke from the site. Normally coke was transported using the railways, but the rail industry had gone on strike in support of the miners, showing a solidarity among workers against what they

saw as unjust action by the government. The initial picketing only took place for two days a week at the instruction of the NUM. Lorry drivers at the time had a heavy police escort to keep them from harm, but this did not deter striking workers from manning the picket line at the entrance to the site. One of the more notable arrests at the site was that of Arthur Scargill, President of the NUM, on 30 May 1984.

The famous Battle of Orgreave took place on 18 June 1984 and would be a major turning point in the 1984/85 miners' strike. Both sides boasted considerable numbers: 5,000 pickets and 4,500 police, some of the latter with horses and dogs. This would be one of the country's first examples of police using riot gear when dealing with picketing miners, and it would later see some miners awarded around £500,000 in compensation due to police assault and other unlawful actions. Estimates of the number of casualties show many more pickets were injured than policemen. Picketing at the site was quickly called off for the following days as the miners did not want a repeat of the battle; many of them still bear the physical and mental scars.

In later years, documents uncovered by the Commons House Affairs Committee would culminate in the formation of the Orgreave Truth and Justice Campaign, spearheaded by Barbara Jackson, a well-known figure in the coal mining community. Between 2012 and 2015 there was an open IPCC (Independent Police Complaints Commission) investigation into the events of the day, but its findings were not pursued due to the length of time since the incident.

A famous picture was taken here on this derelict bridge showing the beginning of a stand-off between the strikers and police close to the entrance of the Orgreave coking plant. Today the bridge has been fenced off and is no longer accessible.

Thurcroft, a village south-east of Rotherham, can be used as a case study for how coal mining influenced the local economy and provided jobs and a purpose for the surrounding community in the twentieth century. Before the mining industry arrived, Thurcroft consisted of a few farmhouses. The Rother Vale Colliery Company began to take interest in the area as it was close to the Barnsley coal seam, with initial excavations taking place at the turn of the century. The colliery was sunk in 1912, comprising two mine shafts (including winding wheels), a rail network to help transport the coal, as well as all the necessary infrastructure for the successful running of a mining operation. At its height the colliery employed much of the local population, including foremen, electricians and faceworkers, and its expansion led the local coal authority to build houses in the surrounding area. This led to an influx of workers, which also brought entrepreneurs who set up shops.

The main stretch of shops, known as 'the shopfronts', was opened in 1921. By the 1950s there was a fishmonger, a movie theatre, a greengrocer, a butcher, and St Simon & St Jude Church. More houses were built to entice miners to work at the colliery, with housing being part of the contract they signed with the colliery board. The new homes were developed close to the pit and expanded outwards as more miners came with

The impact of mining in the community can still be seen today, such as this old mine cart being used to display flowers as people enter the village.

their families to live and work. Old plans show the initial street plan for Thurcroft, with recognisable names such as Osbert Drive, Peter Street and John Street. Many of these earlier streets were named after local councillors or dignitaries. A pitch near the colliery and brickyard entrance was built to host football and cricket matches. Tournaments were regularly held, pitting local colliery teams against each other.

Notable buildings such as the Welfare Hall, built in the early twentieth century, and the Gordon Bennett Memorial Hall, built in 1983, provided a place for village meetings, scheduled events and local youth clubs. This provided the community with a variety of different groups to join that were different from the typical pub environment.

The colliery was very successful, making sole use of the local Barnsley seam until 1945 when the Parkgate seam, notorious for only being accessible when on your hands and knees, was opened. The pit produced a healthy tonnage of coal each year, approximately 550,000 tonnes by the 1980s, requiring miners from across the United Kingdom to be moved to the village, many from the north. The community began to expand once more, with the brickyard next to the colliery providing another source of employment. By now several pubs had been established in the area, the first having been opened back in 1926. Many of these pubs would become ingrained in the village's history, such as The Thurcroft

Remnants of a maintenance shed on Thurcroft cricket pitch, which was once a hive of activity when the pit was operating.

Hotel, The Top Club, Thurcroft Miners' Institute and The Ivanhoe. Current residents still have fond memories of the many social clubs and day trips that came about from the strong sense of community.

Religion always played an important part in the lives of the local villagers, with the Wesleyan Church on Woodhouse Green being built in 1930 and St Simon & St Jude (for Church of England parishioners) which opened in 1939. The former is currently a community hall used for a variety of activities, whereas the latter is still used for its original purpose.

The mine was a place of pride for the locals, so it is no wonder that the area was badly affected by the miner's strike, which raised tensions in the village. At the time of the strike it was recorded that there were approximately 50 clerical and support staff, 6 canteen staff, 80 deputies and 720 NUM-registered miners, making a total staff roster of 856 local workers. Many families had worked at the colliery for generations and saw the recent government actions as an attack on their way of life and sense of community. What was experienced in Thurcroft was repeated across many of the neighbouring mining communities, such as Dinnington and Kiveton Park.

The miners' strike of 1984/85 caused a massive upheaval in the social fabric of the area, and the closure of the coal mine in 1992 exacerbated this issue, although it has to be stated

St Simon and St Jude's Church is still used by the community today.

The Wesleyan Church has been transformed over the years and is now used for various local activities including acrobatics.

The remainder of the spoil heap at Kiveton Park Colliery. Rewilding of the area has caused dramatic changes and has made it a pleasant place to visit.

that the community has bounced back in recent years; many organisations are now active in the community helping to make sure that local people can find work and purpose. The lasting impacts of the colliery can still be seen in the community. The spoil tip of the old colliery has been planted to provide a place for people to walk and enjoy nature; its previous purpose would be hard to discern. A landfill site has also opened at the far end of the colliery, although it is not noticeable when walking around the main rewilded section of the pit. Some of the original buildings and structures, such as the weighbridge, for lorries entering and leaving the colliery, foreman's houses, and the release valves for any remaining gases in the pit, can still be seen when walking around the area; it can be difficult to pinpoint where the other structures stood, however, due to the amount of greenery now present at the site.

It was common for miners to take a shower before leaving work after a shift in the pit, and the remnants of the shower block can still be seen today close to the pit's entrance. A part of the old colliery railway track has also been developed into a bike route that connects it to the nearby town of Dinnington. The route still shows signs of its railway history, including many iron bridges crossing the track and leftover ballast which has been shaped into banks for the cycle trail. During the early 1990s you could still see the railway sleepers stacked at the side of the disused track, as well as rubber track supports.

This picture was taken in the 2000s and shows the extent of the spoil heap on Thurcroft pit top.

The spoil heap Thurcroft pit top had trees and other foliage planted. Close to this location were the original pit buildings, which is hard to imagine when visiting today. The gas release valves can be seen in the background of this picture (in the gated structure).

Remains of a bridge that spanned one of Thurcroft Colliery's railways. During the late 1990s soot marks could still be seen on the underside of the bridges from when steam engines were used.

Reservoirs that were used to pump water from the pit can still be seen, although some of these have been drained and filled in to prevent accidents. The remaining bodies of water now provide a great natural resource for the area, providing local wildlife with a haven away from the busy village.

The closure of the pit at Thurcroft in 1992 caused mass unemployment. Some of the workers received sizeable redundancy payouts, but this wasn't accompanied by much financial advice about how to invest the money. This affected the majority of working-age men in the village, as 568 of them were employed at the mine in 1991. Unemployment would remain a constant problem for many ex-miners, with over 40 per cent still looking for work twenty-five months after the closure of the pit. Many residents felt a sense of loss as their community drastically changed with the closure; some noted a deterioration of the village, with crime increasing.

The pit lane to Thurcroft Colliery as it can be seen today. The weighbridge was at the end of this road and the pit foreman's houses, known as the villas, are on the left-hand side.

Like elsewhere around Rotherham, new housing estates have been set up on derelict industrial sites such as the old colliery, increasing the local population to record numbers. The population of Thurcroft in the 2011 census was 6,900, a marked increase from its early days as a small mining village. The industrial estate towards the north end of the village was established in 1967 and has been developed to include a garage, a van hire business and the Homepride factory (now known as Greens Desserts), which has been at the same location since 1979. There is a website about the colliery, providing a bountiful resource for any reader wishing to learn more about the mining industry and the positive impact it had (and continues to have) in the village. There is also a wealth of information in the local library regarding the village's mining heritage. (Links to these resources can be found in the bibliography)

The impact of mining in the Rotherham area cannot be overstated, forging a powerful sense of community with its own unique folklore. One of the most striking tales was told by a miner at Silverwood Colliery during the 1980s who claimed to have come across a mysterious light deep in the mines. On closer inspection he could see it was a fellow miner, but as he drew closer he noticed that the person in question had no face. Another incident was reported in the same decade at Dinnington Colliery, where a story circulated among the workers of a phantom miner haunting the tunnels in a disused district. Local newspapers at the time reported on this event. Each mine had its own paranormal stories,

A memorial to Thurcroft Colliery in the form of a winding wheel. Many villages in Rotherham have similar monuments in honour of their local colliery.

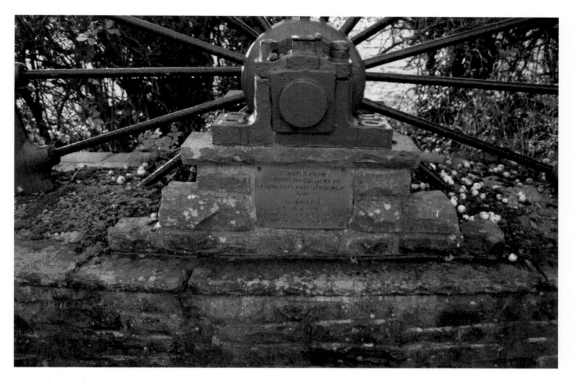

Plaque showing that this particular winding wheel located in Thurcroft was donated by the nearby Dinnington Colliery. Relationships between old mining villages are still strong and respectful.

including a phantom miner at Wath Main Colliery in the 1970s and a shocking tale from Kiveton Park Colliery during the 1980s of a repairman so terrified that he ran more than 2 miles to get out of the pit. To this day no one is sure what scared the man, but it is safe to assume he did not return to that part of the pit.

Ghostly miners are not the only paranormal happenings reported in Rotherham, as stories of poltergeist hauntings are very common. One notable example in Swallownest caused the owners of the house to move out shortly after moving in. Unexplainable draughts at an old cottage in Throapham also had a similar effect alongside doors closing on their own accord and a piano heard playing, despite nobody on the street owning one. The sound of a phantom piano is a common occurrence in the local area, also being reported at a house on Lordens Hill in Dinnington during the 1940s. Throapham is also said to be visited by the so-called Green Lady, who haunts the remnants of an old manor house that was demolished in the twentieth century.

Rotherham is famous for its many pubs, and these also come with a variety of paranormal folklore. At the Saxon Hotel in Kiveton Park, a whistling ghost is said to be heard in the cellar. One of the oldest pubs in the area, South Anston's seventeenth-century Loyal Trooper, has had numerous reports of unexplainable occurrences in the bar area. North and South Anston are home to an interesting myth that rock from the nearby quarry was used to build famous landmarks such as the Palace of Westminster and the

Record Office in London. The villages are also said to be home to a Saxon burial ground, and Butchers Orchard is supposedly built on the site of an ancient battle.

Nearby Laughton en le Morthen also has its share of ghostly encounters. It has been said that a ghostly horse and carriage can be seen late at night crossing the bridge next to The Gallows pub. Similarly, a spectral highwayman has been seen in the neighbouring town of Todwick near the Red Lion Hotel, with accounts of motorists being startled by the apparition.

These stories have been passed down for generations, told and retold to become the tales they are today. True or not, they are important as they bring to life the history of the area while also offering captivating stories. Although the author of this book is a sceptic, it is important to preserve local folklore for future generations as it is vital to the fabric of Rotherham.

# New Directions (1991–Present Day)

The collapse of the coal industry and decline of the steelworks deeply affected Rotherham and its community, increasing unemployment to record levels. Generations of families had grown up in certain industries, such as mining, and felt a bond with the associated vocations. When this link was removed it left a void, with no similar employment offered. Some of the coal miners found work at the few remaining pits in the area, such as Maltby Colliery or further afield in neighbouring counties, but many felt the harsh reality of having to live without a guaranteed wage.

Although it was a dark time in the area's history, the closure of the pits paved the way for new industries to be born in the region. Industrial sites became the norm across the area, such as the North Anston Trading Estate near Dinnington, based on a site close to where Dinnington Colliery once stood; Canklow Meadows Industrial Estate; and also Park Gate Shopping Centre, set up on the old Park Gate Steel Company site. Demonstrating

View showing Ship Hill in the present day. The layout of the street has not changed much over the past few hundred years.

*Above and below*: Vista of Rotherham looking towards the city of Sheffield. These pictures were taken at Boston Castle and provide the best views of the town. Magna Science Park and also Meadowhall Shopping Centre can be seen in the distance.

the continuing historical relevance of local place names, Canklow Meadows Industrial Estate derives its name from the setting of the impressive Haworth Hall, demolished in the 1960s after three centuries of occupation.

The creation of these industrial estates allowed jobs to slowly return to the area, although many of today's working-age people have grown accustomed to travelling further afield for work, commuting to places like Sheffield. This is in stark contrast to their grandparents, who most likely worked at the local colliery just a short walk from the family home. Although many mines and steelworks have mostly closed, there is still a great passion for the history of the industry and its influence on local culture. Many local historical societies put on open days where likeminded individuals can get together to share their knowledge.

The centre of Rotherham has been rebuilt many times over the years, unearthing some interesting items from the past in the process. For instance, a manorial bakehouse was uncovered when All Saints Square was first constructed. The buildings on the site were demolished in the 1930s to make way for a bus terminal that was used until the late twentieth century.

The town has seen much transformation over the past half century, with the decline of certain industries leading to the demolition of old buildings and, in some cases, the erection of housing in its place. Many areas no longer resemble how they used to look, such as the area near Greasbrough Road, a ten-minute walk from the current centre

All Saints Square as it is today.

All Saints Square in the 2000s showing the fountain in all its glory.

of Rotherham. In the 1950s the area was filled with houses, bustling local pubs and transport links to outlying areas. Most likely due to clearance of old houses no longer fit for purpose, buildings on what is now North Drive were razed and built anew. Greasbrough Road is now an industrial estate, and a walk down it shows no signs of any housing. A local school has been taken over by a children's play centre which still displays its impressive architecture. Rotherham's driving test centre also operates on this site, alongside a large gym. People walking these streets and working in these businesses will have no idea of how busy this area used to be and how many stories have been lost due to such changes.

Many buildings and streets still exist to give a glimpse into the past of the town, and below is a recommended walk that will show you some of these interesting sites. Start on Moorgate Road near the current business known as the Big Smoke. This building was constructed in early twentieth century and has had many functions, including being a local pub called The Florence Nightingale. Moorgate House was also based directly across the street from this location, although it has been demolished in recent years. If you turn left at the crossroads of the A6178 you will pass on your right the site of a nineteenth-century primary school, today a nursery. Turning right at the bottom of the

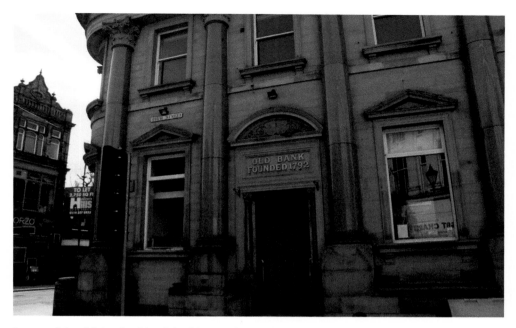

Image of the old Scotland bank building at the bottom of High Street which has been a consistent presence in the town since 1792.

Disraeli's, known by many names over the years, was a regular haunt for Rotherham residents. Recently it has been made into a magic shop, but is currently closed to the public.

hill and making your way towards Westgate will take you past many well-known pubs, such as the New York Tavern and also The Cutler Arms, a regular haunt of local residents since 1825.

Continuing to the end of this street will bring you into the town centre, where you can make a left down Corporation Street past the newly built Minster Gardens. Excellent views of the main church can be enjoyed here, and you can also see some of the older buildings such as The Red Lion pub. At the end of Corporation Street is the old Regal Cinema, most recently a Mecca bingo hall. The final part of this walk takes us to the end of this road, with Our Lady on the Bridge Chapel on the right-hand side and Rotherham's main railway station on the left after you have crossed the bridge. From this location you can see some of Rotherham's impressive architecture.

Many projects have been set up over the last few decades to help rejuvenate Rotherham's green spaces. One of the most successful of these projects has been the development of Rother Valley Country Park, which attracts around a million visitors

The Cutlers' Arms, open since 1825, can be seen today on Westgate with its striking red brickwork.

The Bridge Inn as seen from the River Don.

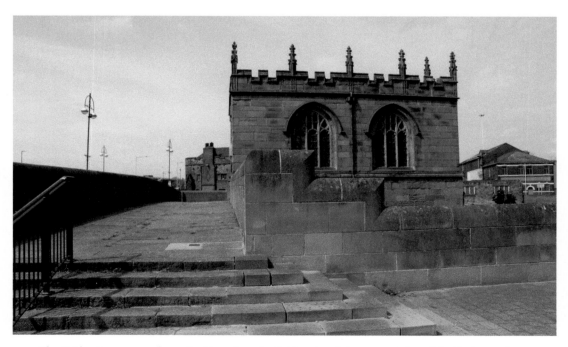

The Bridge Inn as seen from the Chapel on the Bridge. A pub has operated on this site in one form or another since the 1700s.

each year. The site was developed in the 1980s on a disused plot of land previously used by local mining operations, with two large lakes formed in 1982. To flood the old workings of the open-cast mine that used to operate there local brooks and rivers were diverted to ensure enough water entered the two lakes (The levels are controlled to this day to prevent flooding). The park also boasts a large variety of bird species as well as vast wooded areas surrounding the water. Visitors can take part in activities on the water such as kayaking and cable waterskiing. It has been noted that the park brings in over £5 million annually, providing a welcome boost to the local economy. Another successful project close to the park is Gulliver's Valley, a children's theme park opened in 2020 which is built close to Waleswood industrial estate.

Wentworth is still a major tourist attraction in Rotherham, hosting a garden centre and café as well as the stately home of Wentworth Woodhouse itself, which has recently benefited from work on its facade. Many of the historic structures mentioned in this book are still standing and available to visit, such as Keppel's Column and the Rockingham Mausoleum at Wentworth. On a clear day many of these landmarks can be seen directly from Wentworth Woodhouse, providing an amazing photo opportunity.

Rotherham College has continued to develop and now also includes a university campus where it offers a wide range of higher education degrees. This has given people in the local area greater access to higher education courses without having to travel to Sheffield for study. Recently they have also offered free online distance learning courses for adults to upskill in certain areas such as IT and Health & Social Care, giving further opportunities for people who may not have the time or money to commit to a full-time course.

On a clear day many of the follies at Wentworth can be seen from much of the surrounding area. This example shows Keppel's Column (seen in the distance on the right-hand side) being viewed from Hoober Stand.

Entrance to the Clifton Building, which is part of modern-day Rotherham College. Rotherham College has provided education to Rotherham's residents since 1853. The old college crest can be seen on the right-hand side.

The entrance to the old technical college, part of Rotherham College, which used to be the home of many technical drawing courses for mine workers in the 1960s.

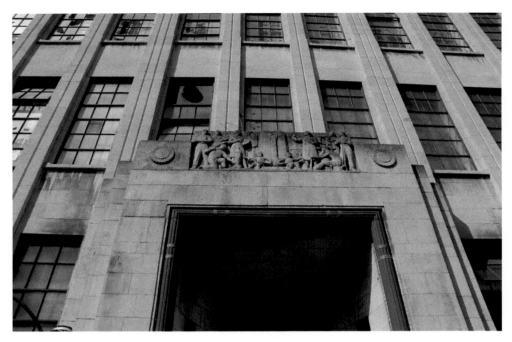

Close-up of the intricate carvings above the old technical college entrance.

The view of the bottom of High Street which is surprisingly similar to old photographs that can be found in Rotherham Archives.

The centre of Rotherham has recently been revitalised, with new paving being laid in the town centre. Many shops have left the town due to reduced footfall, but new businesses have begun to open in the town, including a new vegan takeaway close to Rotherham Minster.

Regeneration of the old Forge Island site has continued after the Tesco store on the site was demolished. There are plans for a multiplex entertainment area, which would provide a much-needed boost to the entertainment sector, complementing the shows currently offered by the Civic Theatre.

Sport has always played a large role in Rotherham's community, most notably football. Rotherham United Football Club started life as two separate teams, Rotherham Town and Rotherham County, merging in 1925 to become the team we know today. The Rotherham United Auxiliary was founded on May Day in 1925 for people to show their support for the club, with the official Rotherham United Supporters' Club founded on 16 October 1930 at Millmoor Hotel. Both groups would be amalgamated to create one supporters group on 5 December 1964. This group still exists and continues to support the team.

The original home of the club was Millmoor, bought in 1948 for a total of £5,500. The new stadium for the club, the New York Stadium, was built in July 2012. Built on the former factory site of Guest & Chrimes, which manufactured the famous fire hydrants

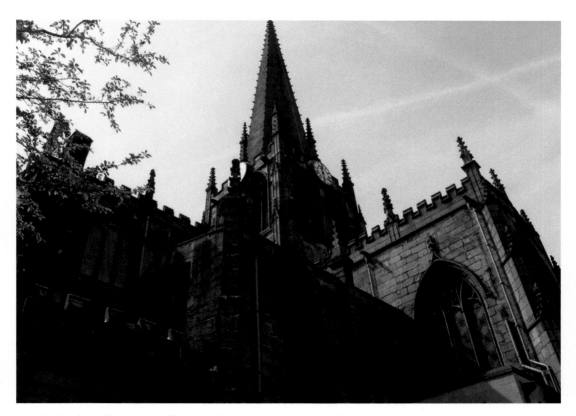

Rotherham Minster is still a major landmark in the centre of town.

Regeneration in the town can be seen in the paving outside the Town Hall. This process was started in the 1990s and continues to this day. Note Rother Minster's spire seen overhead as well as the Cross Keys pub, a popular haunt that is unfortunately closed at the time of writing.

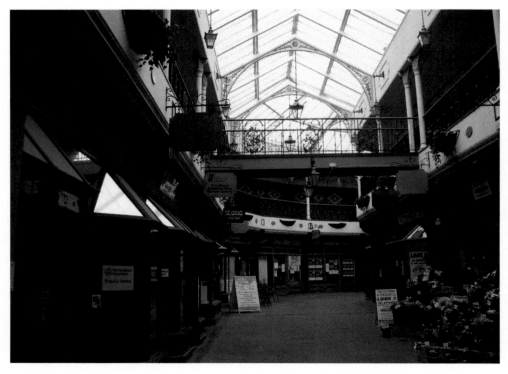

Another example of regeneration in the town is the repurposing of old buildings, as can be seen here with the third iteration of the Town Hall being converted into a shopping arcade.

used in New York City (the stadium towers over the nearby buildings and is situated a ten-minute walk from the town centre). Boasting a matchday capacity of 12,000, it also has conference facilities. At the time of writing, Rotherham United FC currently competes in the Championship League, the second tier of professional football in England, having last been promoted in 2022. The town commemorated this achievement by putting on a bus parade, taking players and other important staff members from the New York Stadium across to the Town Hall. It was a popular event attended by many of the town's avid supporters of the club.

Football is not the only sport closely followed in Rotherham, as the local rugby team Rotherham Titans has continued to go from strength to strength and is currently competing in the National League 2 North for the 2022/23 season.

The town hosted fixtures for the Historic UEFA European Women's Football Championship in 2022, providing an opportunity for the area to show its positive aspects to a global audience. There were four matches planned that involved a wide variety of countries, including France and Belgium. Rotherham was also chosen to host a quarter-final match which took place on 23 July 2022 between France and the Netherlands, resulting in a 1-0 victory for the French side. Opportunities to work as a volunteer at the matches had been advertised, and it is clear that many residents took this opportunity to give something positive back to their community.

The current home of The Millers, New York Stadium, as seen from the dual carriageway.

An amalgamation of past and modern architecture. On the border of Rotherham and Sheffield was the impressive Tinsley Cooling Towers next to Meadowhall Shopping Centre. The towers were demolished in 2008.

Magna Science Adventure Park, built on the site of the old Templeborough steelworks, provides a vital learning tool for children and young adults across the borough. The current site was designed by the architecture firm Wilkinson Eyre at a cost of around £53 million. A plethora of science-based exhibits and activities enable visitors to engage with these subjects in a fun and interesting way. The site also holds the annual Rotherham Beer Festival which is one of the highlights on the town's calendar, bringing many types of locally and nationally brewed beer together in a social setting that also showcases local bands and many different food vendors.

# Conclusion

Although there are still some issues in the town, there are measures in place to ensure everyone in Rotherham can prosper and improve their lot in life. This book has taken us from the town's inception as a small market town through its height as a major producer of steel and coal. Although much of its industry has declined or moved to other areas of the country, the town still has a lot to offer culturally as well as providing a place for future generations to grow.

New ways of generating energy, as opposed to coal and steel, are being explored in the region. Here we can see blades being transported for the construction of Penny Hill wind farm which started to generate electricity in 2013.

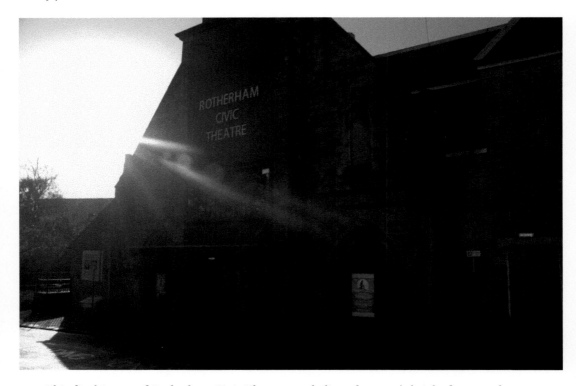

This final image of Rotherham Civic Theatre symbolises the town's bright future as long as regeneration efforts continue.

During the recent Coronavirus pandemic the town pulled together and showed its tremendous community spirit, reminding everyone just how compassionate the people of the town can be.

Ongoing developments in Rotherham's centre will hopefully revitalise this once great market town so that it can again become a significant hub for traders and businesses. This author hopes this book will bring Rotherham's history to the forefront for upcoming generations so that these stories will not be lost to time, and that it might rekindle a passion for local history in the residents of the town.

# Bibliography

CHAS C. PARRY, D. WADDINGTON, D (1995). *Redundancy & After.* PAVIC Publications, Library & Learning Resources, Sheffield Hallam University. United Kingdom.

CROWDER, F. and GREENE, D. (1971). *Rotherham.* SR Publishers Limited. United Kingdom.

ELLIOTT, B. (2006). *South Yorkshire Mining Disasters Volume I: The Nineteenth Century.* Wharncliffe Books. United Kingdom.

ELLIOTT, B. (2009). *South Yorkshire Mining Disasters Volume II: The Twentieth Century.* Wharncliffe Books. United Kingdom.

GUEST, J. (1879). *Yorkshire Historic Notices of Rotherham; Ecclesiastical, Collegiate, and Civil.* United Kingdom.

GIBBON, P. and STEYNE, D. (1986). *Thurcroft: A Village and the Miners' Strike.* Spokesman. United Kingdom.

HALL, C. (1996). *Rotherham & District Transport: Volume 1.* Rotherwood Press. United Kingdom.

HEYWOOD, S. and BARKER, D. (2015). *South Yorkshire Folk Tales.* The History Press. United Kingdom.

HUNTER, J. (2018). 'Newcomen-type pumping engines in collieries and ironworks on the north side of the Don valley in the Rotherham area of South Yorkshire in the eighteenth century', *The international journal for the history of engineering & technology*, 88(1), pp. 1–36.

ILONIEMI, L. (2000). 'Smelting never looked this good: A Steel Plant transformed', *Architectural record*, 188 (10), p. 33.

JACKSON, M. (2016). *Rotherham Chapel on the Bridge: Legacy of an Archbishop.* Pickards Design and Print Limited. United Kingdom.

JONES, M. (1995). *Aspects of Rotherham: Discovering Local History.* Wharncliffe Publishing Limited. United Kingdom.

JONES, M. (1996). *Aspects of Rotherham 2: Discovering Local History.* Wharncliffe Publishing Limited. United Kingdom.

JONES, M. (1998). *Aspects of Rotherham 3: Discovering Local History.* Wharncliffe Publishing. United Kingdom.

JONES, M. and WARBURTON, B. (1995). *Rotherham's Woodland Heritage: Aspects of Local History.* Rotherwood Press. United Kingdom.

LINAHAN, L. (1994). *Pit Ghosts, Padfeet and Poltergeists.* The Kings England Press. United Kingdom.

LINAHAN, L. (1996). *More Pit Ghosts, Padfeet and Poltergeists.* The Kings England Press. United Kingdom.

MUNFORD, A. (2000). *A History of Rotherham.* Sutton Publishing. United Kingdom.

OFFICE FOR NATIONAL STATISTICS. How the population changed in Rotherham: Census 2021.

ROTHERHAM, I. D. (2015). *The rise and fall of countryside management: a historical account.* Routledge. United Kingdom and USA.

ROTHERHAM ARCHIVES AND LOCAL STUDIES SERVICE. Newspaper cuttings from local newspapers. 1900–2010.

*ProQuest Historical Newspapers: The Guardian and the Observer,* 9 May 1962, p. 11.

THOMPSON, J., BENSON, M. and McDonagh, P. (2015). 'The social and economic impact of improving a town centre: The case of Rotherham', *Local economy,* 30(2), pp. 231–248.

TROUNCE, B. (2015). *From a Rock to a Hard Place: Memories of the 1984/85 Miners' Strike.* The History Press. United Kingdom.

### Online resources for further information on Rotherham
Domesday Open Source Project: https://www.opendomesday.org
Rotherham Libraries: https://www.rotherham.gov.uk/libraries
Thurcroft Colliery: https://thurcroftcolliery.weebly.com/

# Acknowledgements

Thank you to Professor John Palmer, George Slater and Anna Powell-Smith at the Domesday Open Source Project for use of an image from the Domesday Book, Wentworth Woodhouse management and the Wentworth Estate for permission to take pictures of the house and its follies, English Heritage for permission to take pictures at Roche Abbey, and also all the staff at Rotherham Archives.